DEVON
THROUGH TIME
Derek Tait

AMBERLEY PUBLISHING

Acknowledgements

Photograph credits:

Older photographs: The Derek Tait Picture Collection, Steve Johnson, Peter Davies (p. 14 & p. 33), W. H. Burgoyne (p. 17), Mike Williams (p. 22), Marguerite Hommes (p. 26), Sarah Norris (p. 27 & p. 29), Tracy Hartley (p. 28 & p. 30), Scott Henderson (p. 37), Michele Bergin (p. 38 & p. 40), Lisa Inman (p. 39), Kim Precious (p. 86 & p. 91).

Newer photographs: Derek Tait, Graham Skingley LRPS (p. 4 & p. 78), Jon Brierley (p. 12), Brian Mossemenear (p. 14), Steve Mitchell (p. 17, p. 21, p. 26, p. 32, p. 35, p. 36 & p. 66), David Farquhar (p. 18), Sophie Mackley (p. 19), Kevin Garbett (p. 30), Hugi Ólafsson (p. 22, p. 33 & p. 37), Chris Searle (p. 23), Enrique Gadea (p. 24), Colin Boylett (p. 25), Stefan Schafer (p. 27), Tom Bastin (p. 28, p. 39, p. 45, p. 79 & p. 80), Jason Henry (p. 29), Paul Gruet (p. 31), Paul Willis (p. 34, p. 43, p. 54, p. 60, p. 64, p. 74 & p. 76), Chris Elt (p. 38), Catherine Macfadyen (p. 40), Tim Jenkinson (p. 41), Eddie Holden (p. 42), Willie Miller (p. 44), John Whitmarsh (p. 46, p. 51 & p. 52), Ian Nicholson (p. 47 & p. 48), Matt Clark (p. 49), Nick Southall (p. 50), Brian Carpenter (p. 53), Andrew Norris (p. 55), Jon Combe (p. 56), Baz Richardson (p. 57 & p. 96), Terry Cliss (p. 58), David Cronin (p. 59), Chris Angulo (p. 61), Peter Ivermee (p. 62), Richard Harris (p. 63), Helen Rapp (p. 65), David Purkiss (p. 67), Grant Selby (p. 68), Patrick Baker (p. 69, p. 70), Mark Heathfield (p. 71), Phil Mahoney (p. 72), Duncan Chew (p. 73), Anthony Grimley (p. 77), John Yates (p. 81), Andrew Head (p. 82), Kelvin Bennett (p. 83), Marilyn Gornall (p. 84 & p. 88), Sally Clarke (p. 85), Michael Leek (p. 86), Paul Barnes (p. 87), Miles Wolstenholme (p. 89, p. 93), Mark Finn (p. 92), Tyrone Ware (p. 94) and Chris Popham (p. 95).

Thanks also Tina Cole and Tilly Barker.

I've tried to track down the copyright owners of all photos used and apologise to anyone who hasn't been mentioned.

Please check out my website at www.derektait.co.uk.

First published 2012

Amberley Publishing
The Hill, Stroud
Gloucestershire, GL5 4EP

www.amberley-books.com

Copyright © Derek Tait, 2012

The right of Derek Tait to be identified as the Author of this work has been asserted in accordance with the Copyrights, Designs and Patents Act 1988.

ISBN 978 1 4456 0724 5

British Library Cataloguing in Publication Data.
A catalogue record for this book is available from the British Library.

Typeset in 9.5pt on 12pt Celeste.
Typesetting by Amberley Publishing.
Printed in the UK.

Introduction

Devon has been a popular holiday destination for over 100 years. Seaside resorts such as Paignton, Torquay and Teignmouth were very popular with both the Victorians and Edwardians, many escaping their humdrum lives in the city. The introduction of the railway meant that many people could travel cheaply further afield. Previously, resorts such as Torquay and Paignton had been seen as places where people went to convalesce, but in 1902 Torquay, in particular, began to advertise itself as a holiday resort for summer tourists. There were many attractions for the holidaymaker including purpose-built piers which allowed people to stroll along their boards admiring the view or allowed them to attend one of the many end-of-the-pier shows which included bands and music hall entertainment. There were also slot machines, rides, reading rooms and shops. Steamers would leave regularly from the end of the pier taking passengers to close-by tourist attractions. Fairs would set up nearby with ornate carousels, swing boat rides, coconut shies and rifle ranges.

On the beach, children could take a ride on one of the many donkeys kept there for the purpose. Other entertainment included regular Punch and Judy shows, sandcastle building and swimming competitions, races and other events.

Many adults chose to stroll along the pier or the promenade taking in the sea air and admiring the view. Most were dressed in their finest clothes, eager to impress one another.

Hotels and cafés were built solely to welcome the many visitors that came to Devon in the late 1800s and early 1900s. Many thousands of postcards were sent, all showing interesting views, some of which are featured within the pages of this book.

The railway system was extensive with lines travelling all over Devon. Sixpenny specials would leave from places such as Plymouth and take their passengers not only to the seaside but also to many inland destinations such as Dartmoor, where groups would explore the countryside and have a picnic before catching a later train back home.

In the early 1900s, electric trams became very popular at seaside resorts taking people up and down promenades allowing them to enjoy the magnificent scenery. Charabanc trips became commonplace in the 1920s with groups of people heading off to the seaside or countryside in huge cars. Many were works trips taking employees on daytrips during their annual holiday.

Today, many thousands of holidaymakers regularly travel to Devon every year, enjoying all it has to offer, staying in hotels originally built for the Victorians. Much has changed over the years. Many of the piers have closed or have disappeared and most no longer provide entertainment or steamer trips to nearby destinations.

Gone too are the trams and charabancs which have been replaced by vast numbers of tourist-carrying cars and buses. However, many things still remain unchanged including the many cafés selling Devonshire cream teas and ice cream sellers selling cornets and candy-floss.

The photographs within this book show how Devon has changed in the last 100 years or so, and, although much has altered, it is still a beautiful county to visit.

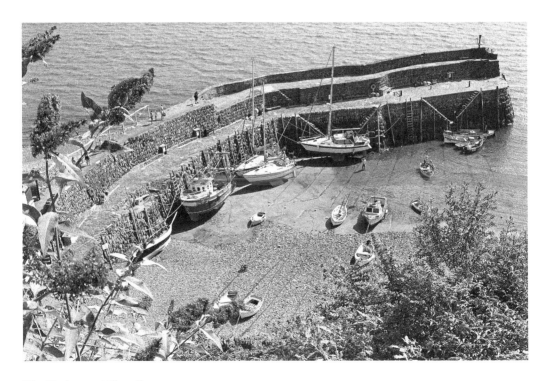

The Harbour at Clovelly

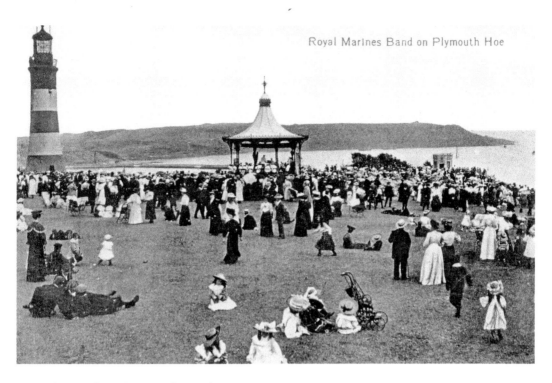

The Royal Marines on Plymouth Hoe

The earlier photograph shows a crowd gathered on Plymouth Hoe where the Royal Marines band is playing. On the left is Smeaton's Tower. The bandstand was cleared away in the Second World War and the metal was used for the war effort.

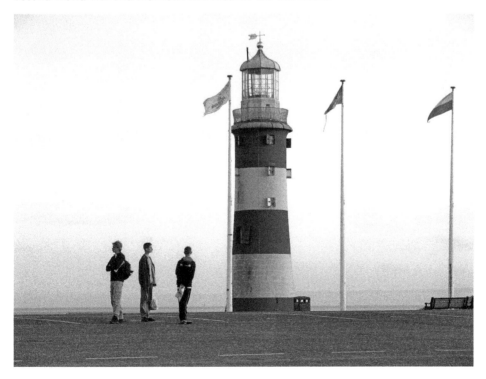

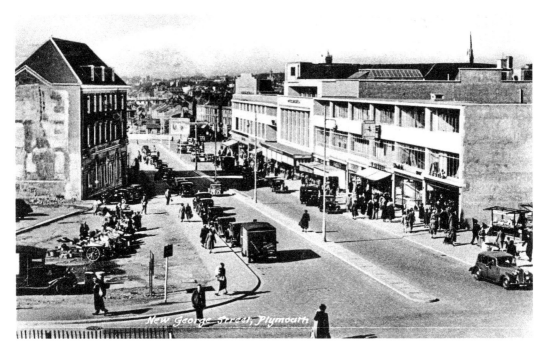

New George Street, Plymouth

The older photograph shows the rebuilding of Plymouth after the Second World War. The newly built New George Street can be seen with the *Western Morning News* building on the left. The later photograph shows New George Street today complete with many shoppers.

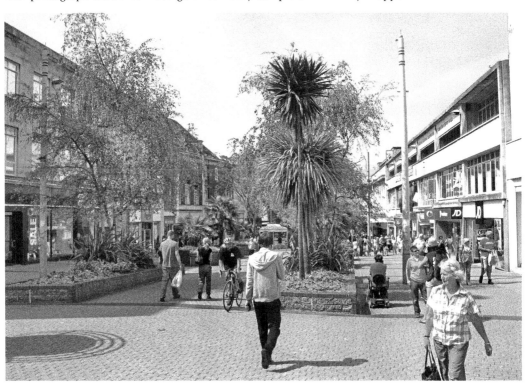

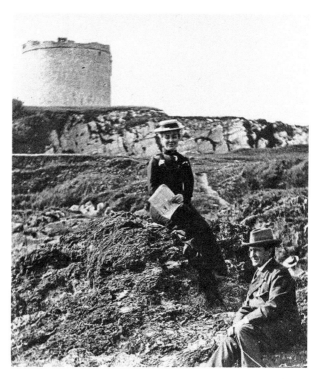

Mount Batten

From the Bronze Age, the people of Mount Batten traded with Europe making it the earliest trading site discovered in Britain. It continued to be used throughout the Iron Age and during Roman times. The tower shown in both photographs was built in 1652. T. E. Lawrence (Lawrence of Arabia) was stationed at the RAF base at Mount Batten during the 1930s.

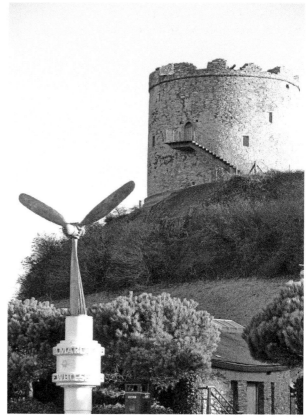

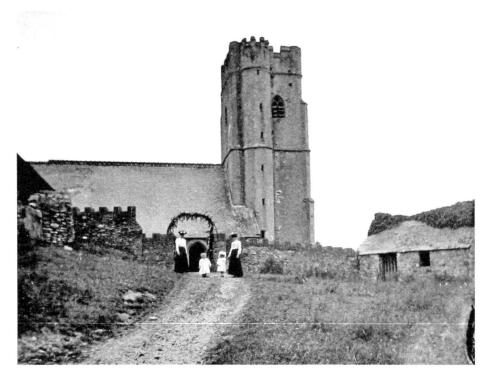

Wembury Church

Mothers and their children pose in front of St Werburgh parish church at Wembury in the first photograph. Three of them are wearing decorated hats. The church was built in medieval times and parts date back to the fifteenth century. The second photograph shows the church from the path leading down to the nearby beach.

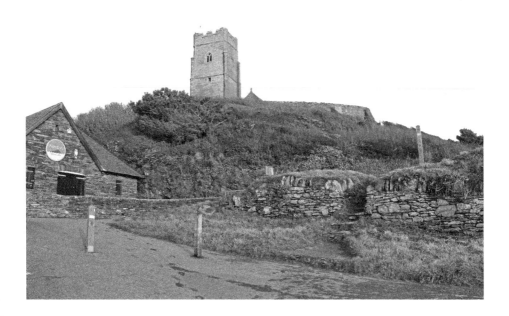

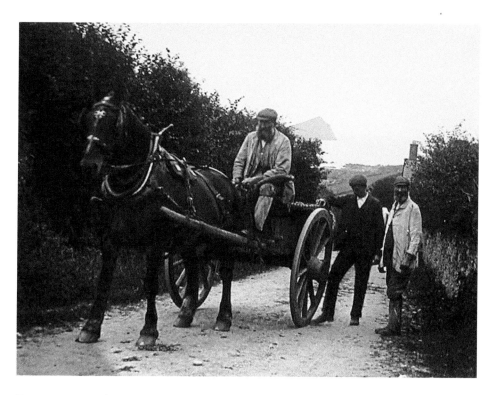

Farmers at Wembury

In the earlier photograph, farmers travel uphill with their recently harvested produce. In the background can be seen the Great Mewstone which was once the home to a man called Finn, who was sent to the island in 1774 for seven years as punishment for crimes including theft.

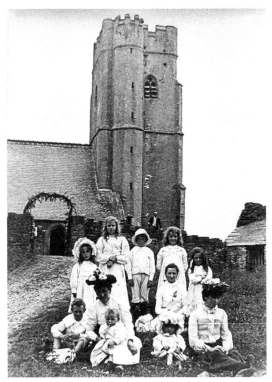

A Special Occasion at Wembury Church
Children are shown in their Sunday best in the earlier photograph taken in front of the church at Wembury. A man is watching the proceedings in the background. The building and its grounds have changed little over the years and the later photograph shows a view of the church from the other side looking towards the beach and nearby farmland.

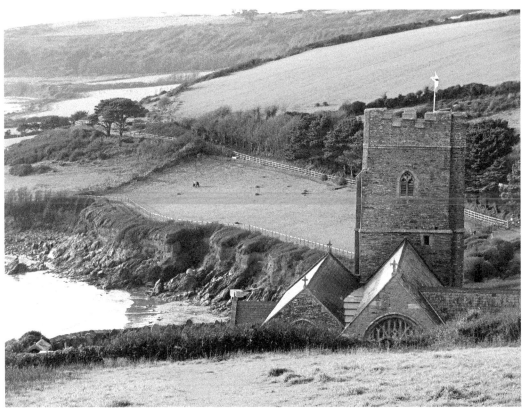

The Village of Noss Mayo

Noss Mayo lies on the southern bank of Newton Creek which is an estuary of the River Yealm. On the northern bank of the creek is Newton Ferrers. The first recorded mention of Noss Mayo was in 1286. The first photograph shows an early view overlooking the village and the second shows the nearby harbour.

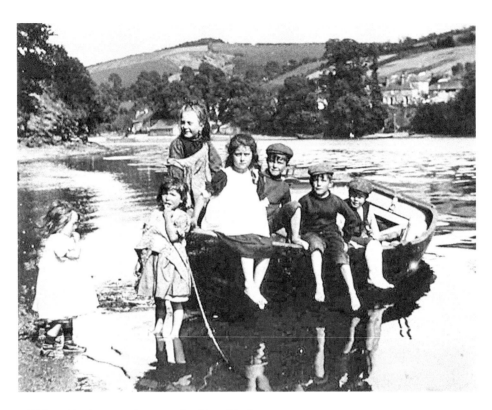

Children Playing on a Boat on the River Yealm
Children enjoy dangling their feet in the water of the River Yealm in the older photograph. The boys are all wearing cloth caps. The later photograph shows people also enjoying a paddle. Many of the surrounding houses are quite old, although many newer homes can be found scattered between them.

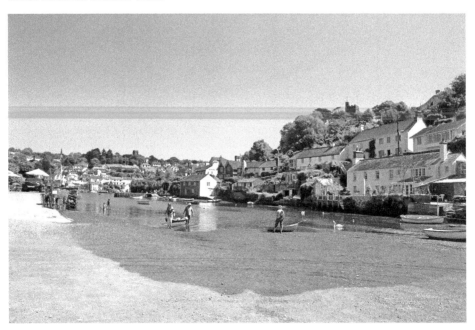

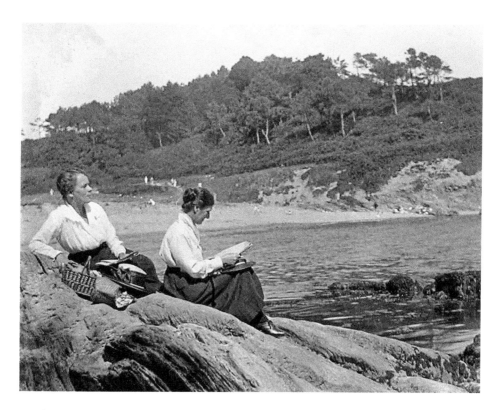

Reading on Mothecombe Beach

The beach at Mothecombe forms part of the Flete Estate and although private, it is open on Wednesdays and Saturdays. Over the years, it has been the setting for many films and television programmes including *International Velvet* and *Hornblower*. Little has changed between the two photographs shown here.

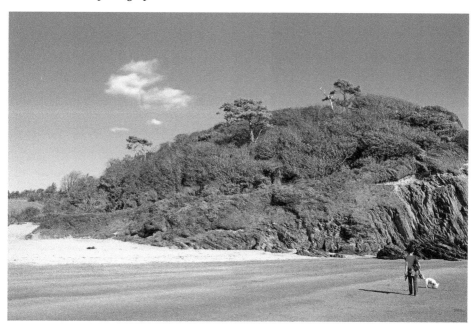

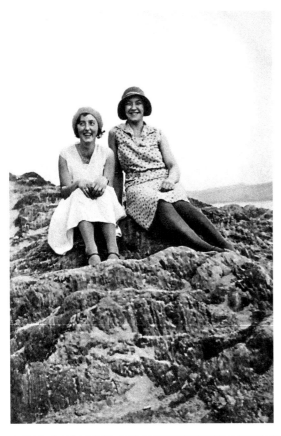

Friends at Bigbury on Sea
Two friends identified only as 'Dot and Trude' enjoy a day at Bigbury on Sea in 1931 in the older photograph. Their clothes certainly sum up the fashions of the day. The later photograph shows many families enjoying a day out at the seaside and a few surfers can be seen in the sea.

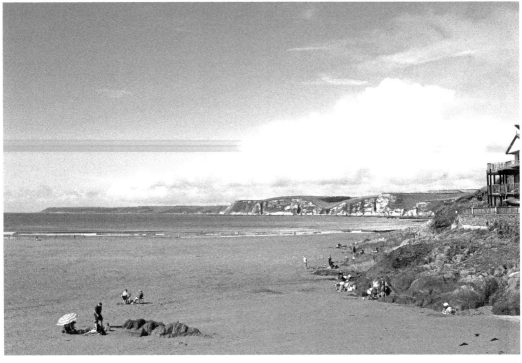

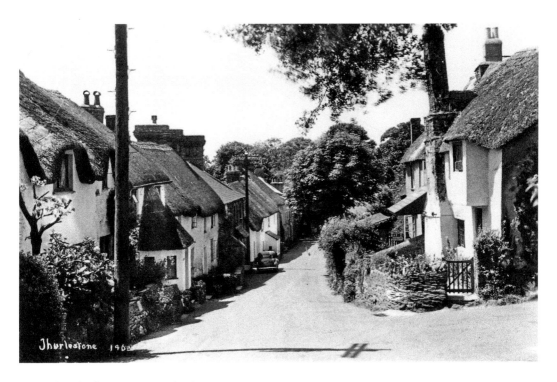

Thurlestone 1908

Thatched Cottages at Thurlestone

The earlier photograph shows the many thatched cottages in the village of Thurlestone. Everything looks very peaceful with just a single car parked down the road. The roadway is a lot busier nowadays with much traffic travelling on its way to the nearby beach which is very popular with both tourists and surfers.

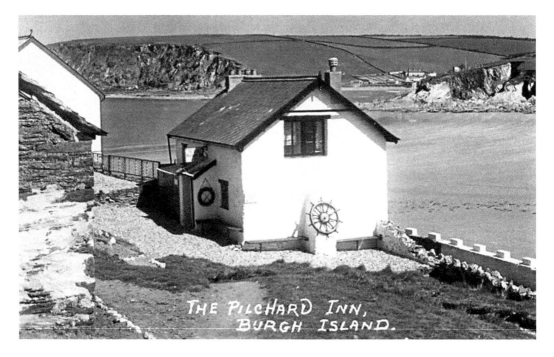

The Pilchard Inn on Burgh Island

The Pilchard Inn is situated on Burgh Island opposite Bigbury on Sea. The hotel there has had many famous visitors over the years including Agatha Christie, Noel Coward and the Beatles. Churchill was said to have met Eisenhower there prior to the D-Day landings. It has also been used as the location for the television version of Christie's novel, *Evil Under the Sun*, as well as an episode of *Lovejoy*.

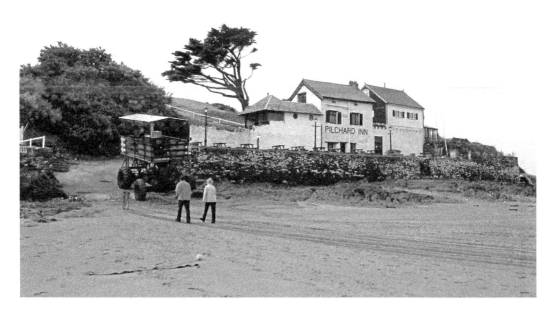

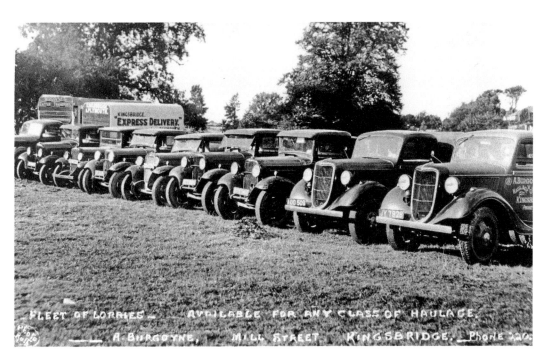

FLEET OF LORRIES — AVAILABLE FOR ANY CLASS OF HAULAGE.
A. BURGOYNE, MILL STREET, KINGSBRIDGE. Phone 220

Burgoyne's Express Delivery Vehicles at Kingsbridge

Shown in the older photograph is the fleet of vehicles belonging to Burgoyne's of Kingsbridge. They offered an express delivery service between Kingsbridge and Plymouth and were also essential in clearing up debris during the Blitz.

17

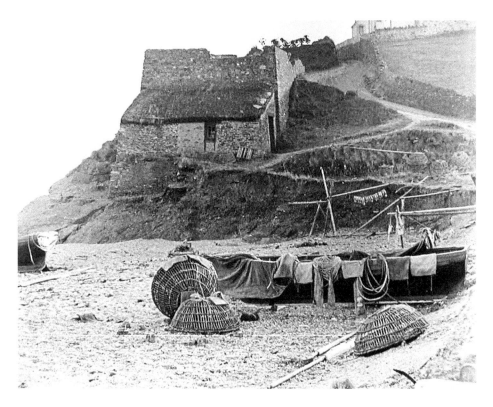

Lobster Pots at Hallsands

The village of Hallsands fell into the sea mainly due to the dredging that took place in the early 1900s during the expansion of the dockyard at Keyham, Plymouth. Sand and gravel were needed and this was taken from the nearby beach. By 1917, only one house remained habitable. Today, the remains of the old village are closed off to the public.

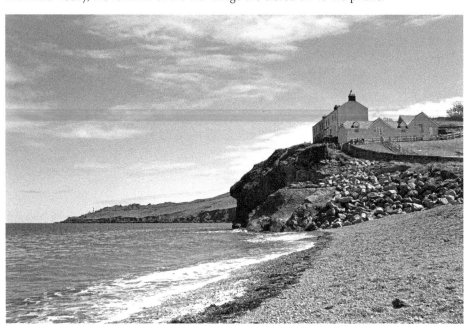

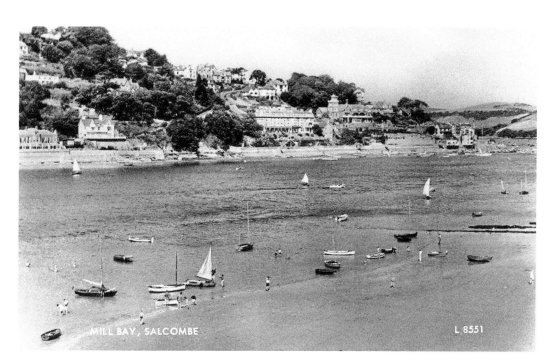

MILL BAY, SALCOMBE L 8551

Mill Bay at Salcombe
Salcombe first appeared in records in 1244 and was the home to fishermen in the 1500s who would travel to Padstow annually for the new herring fishery. Today, there are many luxury yachts in the harbour and properties in the area exceed most people's budgets.

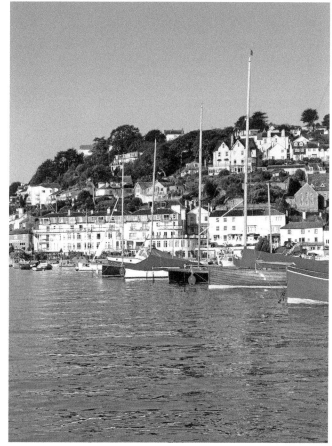

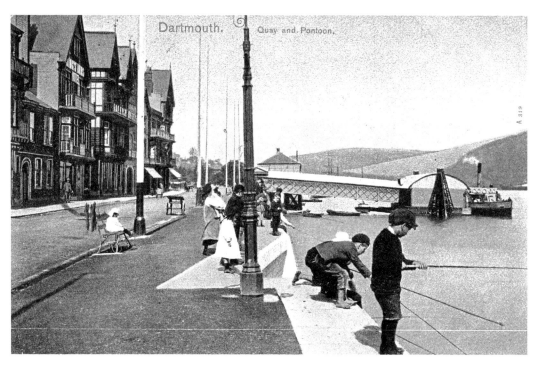

Fishing off Dartmouth Quay
Several boys fish off the quay at Dartmouth in the older photograph. In the background, a steam ferry waits at the end of the pontoon. The later photograph shows the same area from the river. Many holidaymakers can be seen relaxing and enjoying the view.

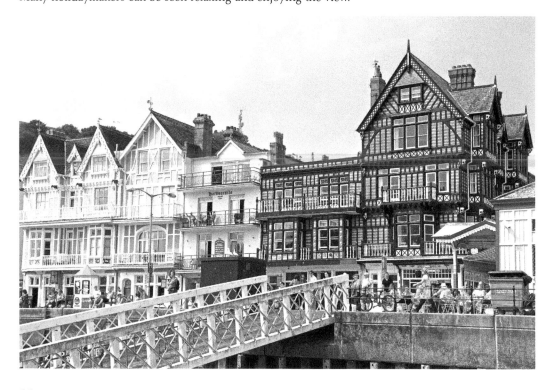

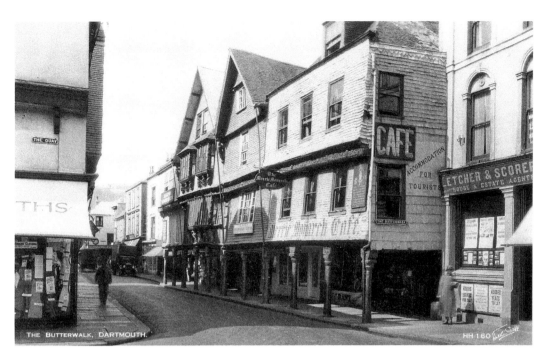

THE BUTTERWALK, DARTMOUTH.　　HH 160

The Butterwalk at Dartmouth

The Butterwalk was built between 1635 and 1640. It was damaged by enemy bombing in 1943 but was later restored. The older photograph shows the 'Merrie Monarch Café' which advertises 'Famous Devonshire Cream'. The building next to it houses an estate agents owned by Letcher & Scorer.

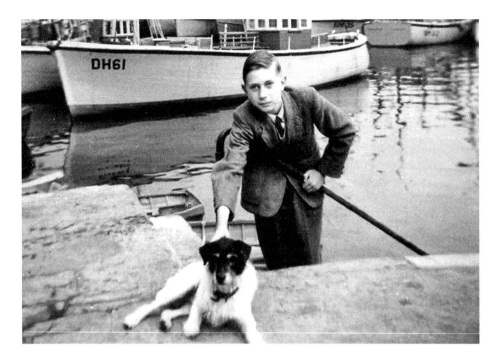

Michael and Chippy at Brixham

The earlier photograph shows Michael Williams, aged sixteen, with his dog, Chippy, at Brixham harbour. During the Middle Ages, Brixham was the largest fishing port in the south-west of England. William Prince of Orange, who later became William III, landed at the harbour in 1688 and a statue is erected there to commemorate the event.

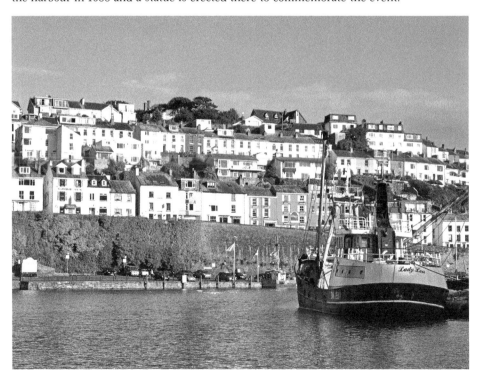

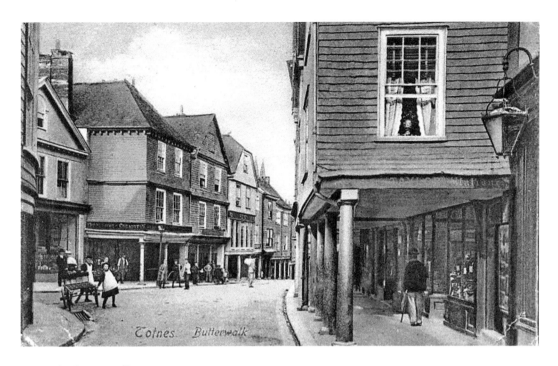

Totnes Butterwalk

The Butterwalk at Totnes

The Butterwalk is a covered walkway which was built in Tudor times to protect dairy produce from the sun and rain. In Fore Street, set into the pavement, is the Brutus Stone which is where Brutus of Troy, the mythical founder of Britain, was said to have first stepped after leaving his ship. Many of the buildings in the earlier photograph remain much the same today.

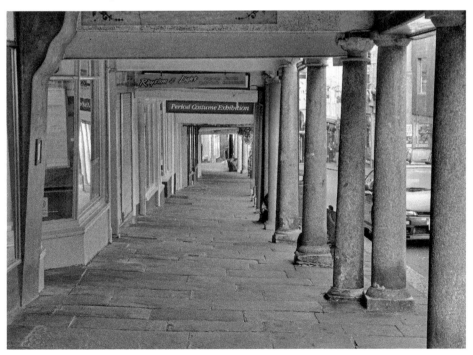

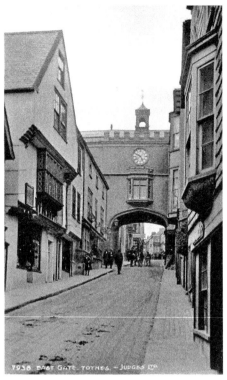

East Gate, Totnes

The older photograph shows the East Gate which was built during Elizabethan times. It was destroyed by fire in 1990 but was later rebuilt. Today, Totnes is the home to many artists, painters and musicians and there are regular markets selling antiques, musical instruments and local craftwork.

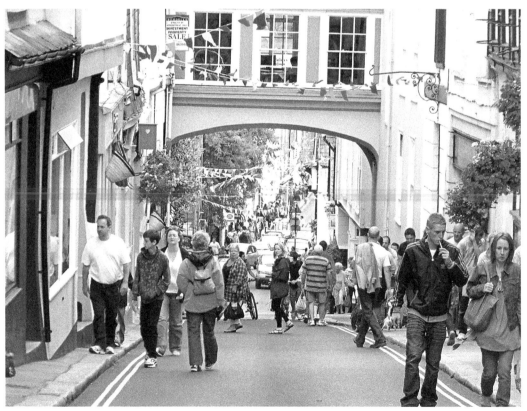

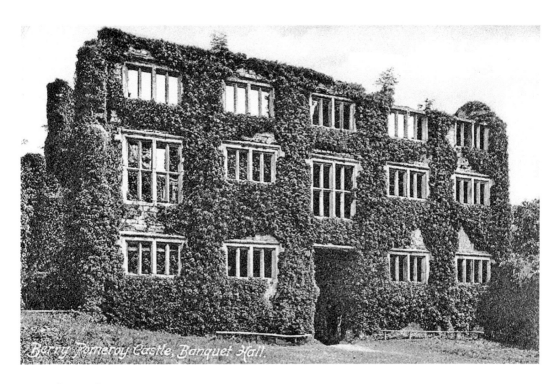

The Castle at Berry Pomeroy

The older photograph shows the ruins of the Banquet Hall which lie within the fifteenth-century defences seen in the later photograph. Building of the house began in 1560 and it was enlarged in 1600 before becoming abandoned 100 years later. Today, the castle is a tourist attraction and welcomes many visitors every year.

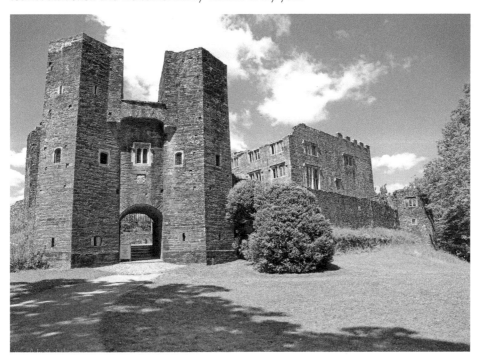

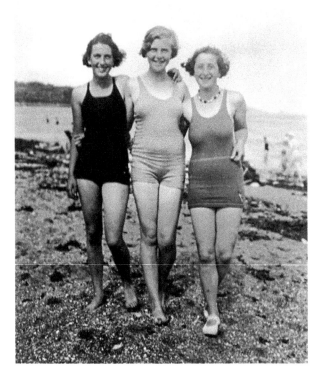

Fun at Goodrington Sands
In the older photograph, three friends enjoy a day out at Goodrington in the summer of 1933. The later photograph shows the view looking in the other direction showing many holidaymakers enjoying the beach. Paddle boats and canoes wait to be hired out in the background.

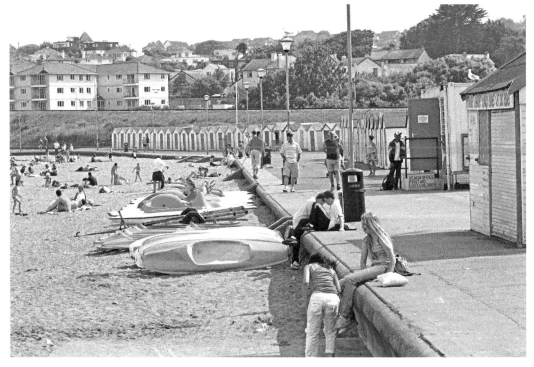

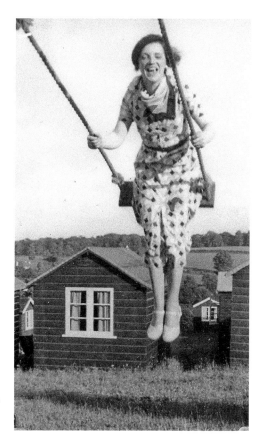

Nellie Lemon at South Devon Holiday Camp, Paignton

The earlier photograph shows Nellie Lemon enjoying herself on a swing at the South Devon Holiday Camp at Paignton in 1935. The holiday chalets can be seen in the background. The later photograph shows a café selling chips and refreshments on the waterfront.

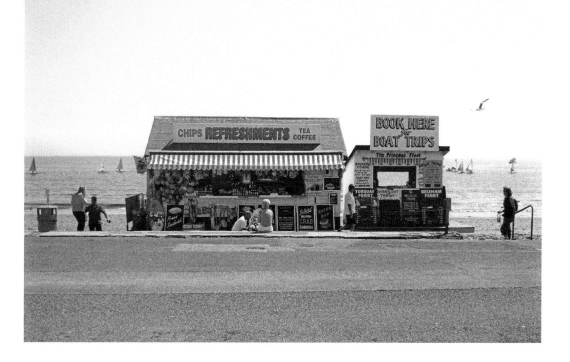

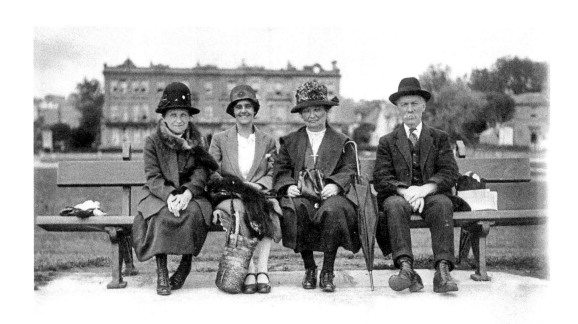

Resting on a Bench at Paignton
A group of friends take it easy on a bench at Paignton. They seem prepared for bad weather and one of them has an umbrella. The later photograph shows the many colourful beach huts which line the seafront at Paignton. Torquay can be seen in the distance.

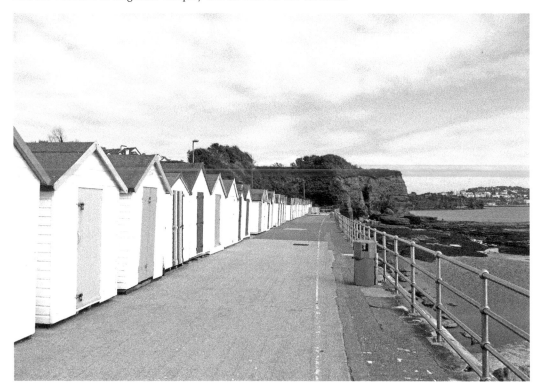

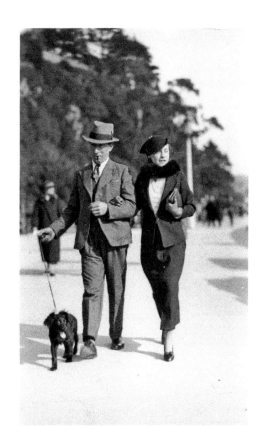

Strolling along the Promenade at Paignton
A well-dressed and well-to-do couple stroll along the Promenade at Paignton as they walk their small dog. The lady has a mink collar, pearls and a clutch bag. The later photograph shows the popular pier at Paignton which first opened to the public in 1879.

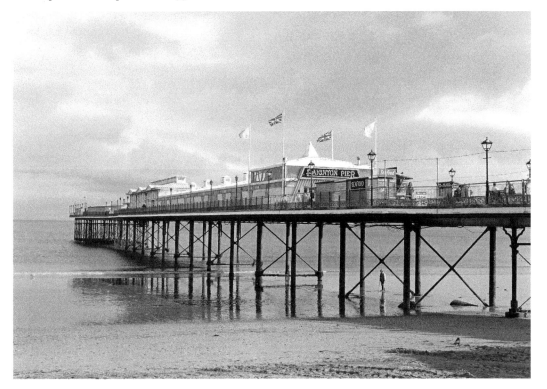

A Happy Group at Paignton

A happy group of holidaymakers can be seen at Paignton in the earlier photograph. One still has his small travelling case. In the background can be seen a hotel where they were possibly staying. The later photograph shows summer visitors to the area and an open top bus is showing tourists all the local attractions.

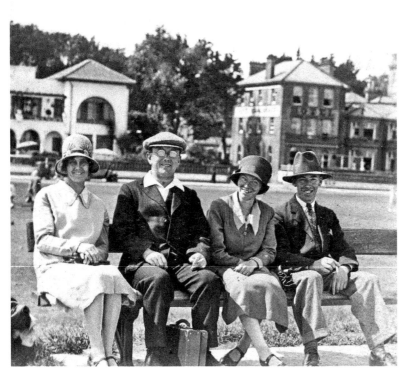

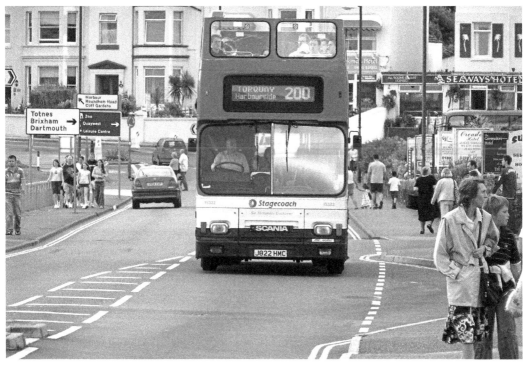

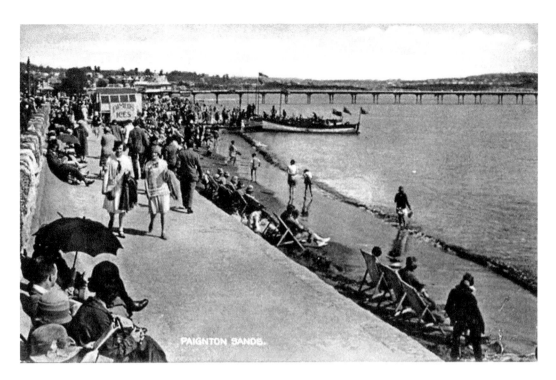

A Busy Day at Paignton Sands

Many people in their finest clothes stroll along the Promenade at Paignton in the older photograph. An ice cream stall and the popular pier can be seen in the background. Boat trips are leaving nearby. The later photograph shows the busy sands today.

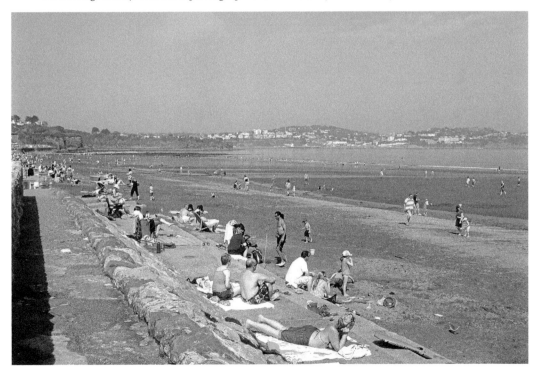

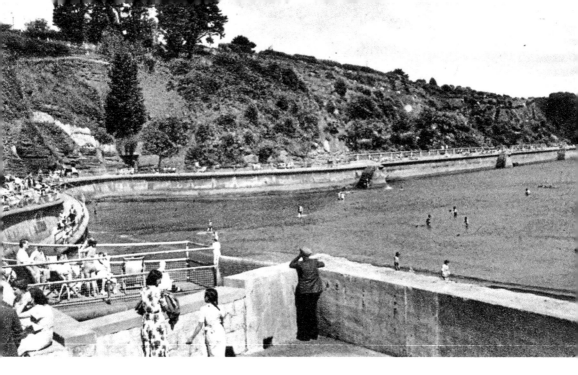

Holidaymakers at Goodrington

Bathers enjoy the sea at Goodrington in the older photograph. Many people look on and relax from the sea wall surrounding the bay. Many summer visitors enjoy the same view in the later photograph. The 'Inn on the Quay' can be seen on the left of the picture.

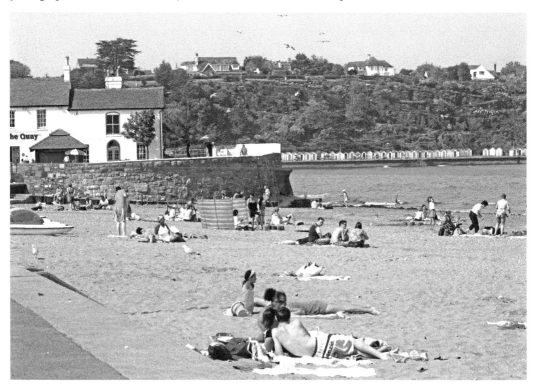

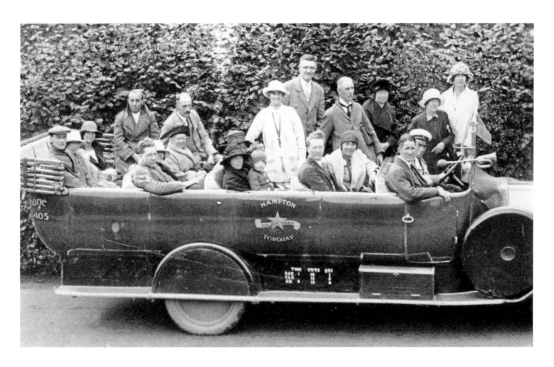

A Charabanc Trip to Glorious Devon

Charabanc trips became very popular in the 1920s, taking friends and colleagues to many popular holiday destinations around the county. This car belongs to Hampton of Torquay and contains twenty-one passengers. The later photograph shows the Princess Pier at Torquay which was built in the 1890s.

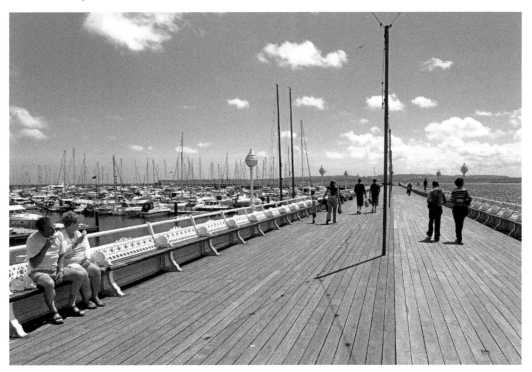

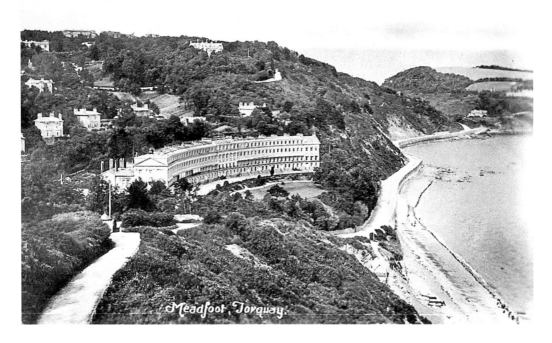

Meadfoot at Torquay

The earlier photograph shows the view looking down towards Meadfoot at Torquay. The popular sandy beach can be seen on the right of the picture. The later photograph shows the view looking the other way towards the beach café which is very busy in the summer months.

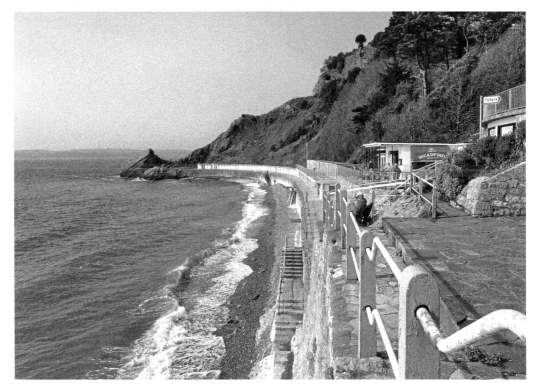

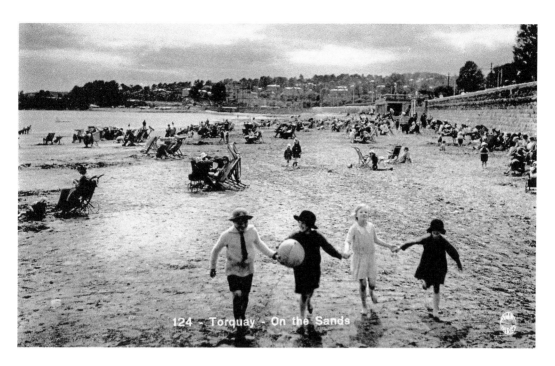

124 - Torquay - On the Sands

Fun at the Beach, Torquay

Four children can be seen playing on the beach at Torquay in the earlier photograph. One has a beach ball. There are many people behind them on the sands. Most are sat in deckchairs and the lady on the left of the picture is busily knitting.

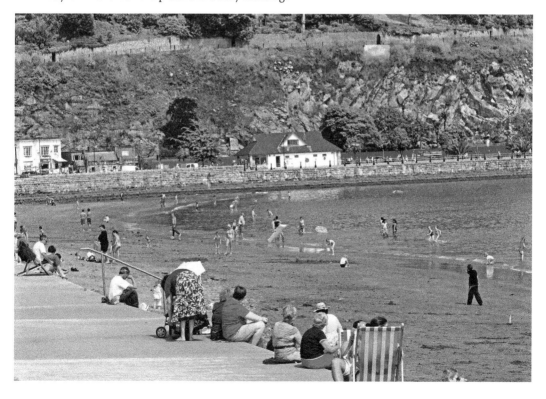

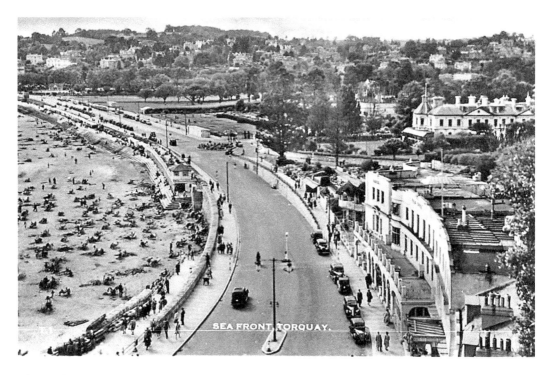

The Seafront at Torquay

The view looking towards the seafront at Torquay in the earlier photograph shows that little has changed over the years. Although there was less transport, there are still plenty of people enjoying a day on the sands. The later photograph shows the busy scene today.

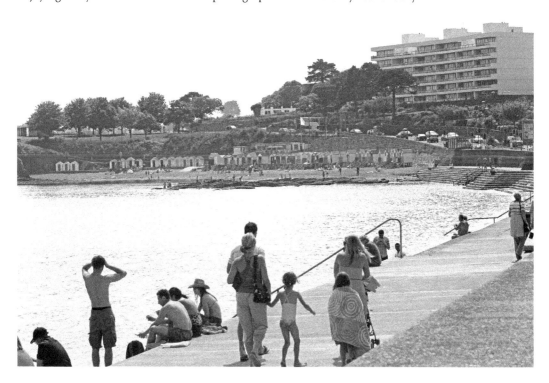

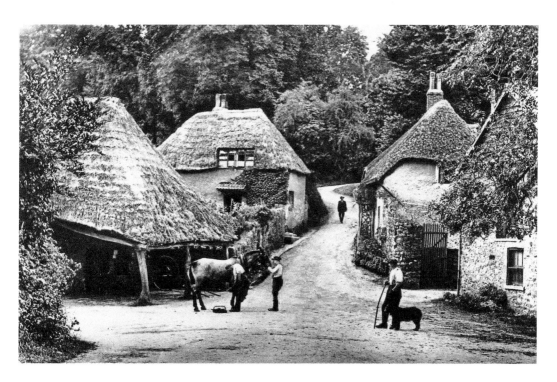

The Forge at Cockington

The older photograph shows the forge at Cockington which has been in the same place in the village for over 500 years. The area is a tourist attraction with its many thatched cottages. The later photograph shows 'Weavers Cottage Tea Shoppe' in the village where Devonshire Cream Teas prove very popular with tourists.

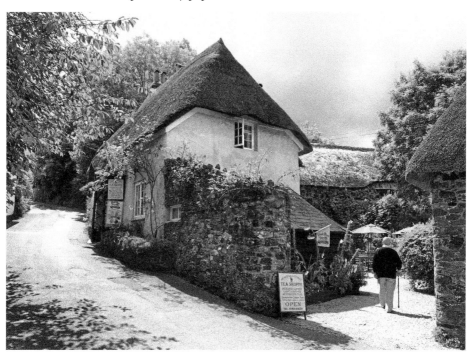

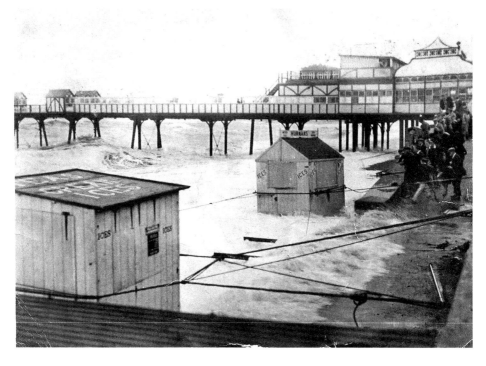

Teignmouth Pier

In the older photograph, ice cream huts belonging to Hurmans are deluged by the incoming tide. In the background can be seen the Grand Pier at Teignmouth which was built between 1865 and 1867. The later photograph shows the colourful entrance to the pier as it is today.

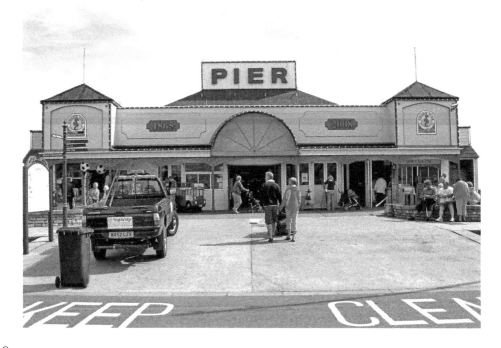

Deckchairs on the Beach at Teignmouth
A family enjoy a daytrip to the beach in the earlier photograph. A booth in the background is marked 'Holiday Snaps' and it's probably the photographer from there who has taken this photograph. The later photograph shows the beach today complete with many small boats.

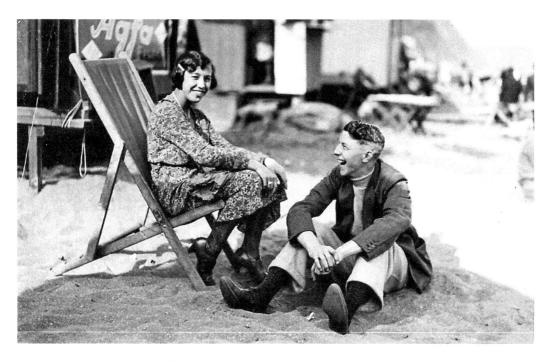

Fun on the Beach, Teignmouth

A happy young couple enjoy themselves on the beach at Teignmouth. A sign in the background advertises 'Agfa Film'. The later photograph shows a beach empty of people but with many boats resting on its shores. Newer apartments can be seen in the background.

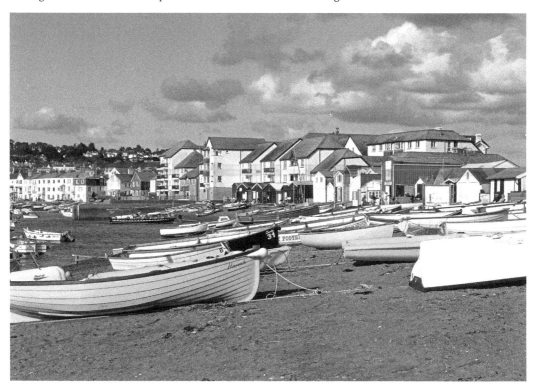

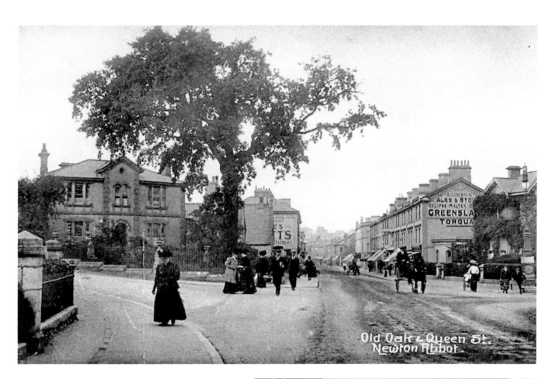

The Old Oak at Queen Street, Newton Abbot

The older photograph was taken in the days before modern traffic and the only vehicle that can be see is a horse and cart. Much has changed in Queen Street over the years. There are many more shops, cars and people, although the modern photograph appears to show a very quiet scene.

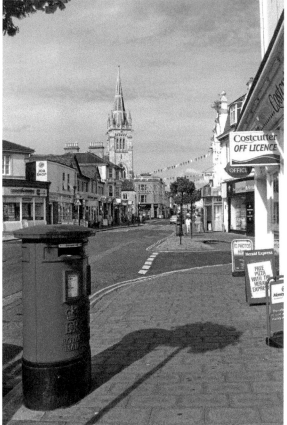

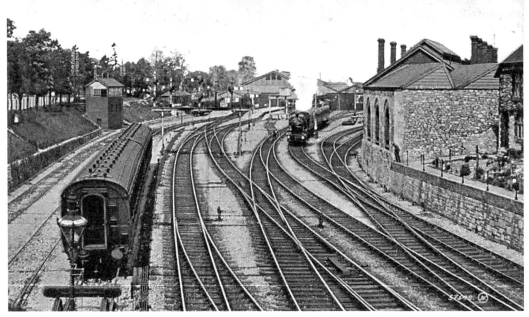

G.W.R. Station, Newton Abbot

The Railway Station at Newton Abbot

The station was opened by the South Devon Railway Company in 1846. In the older photograph, a steam engine pulling carriages can be seen leaving the station on the right. Today, the station is very busy with a constant of passengers, the majority communting to work. The later photograph shows some holidaymakers arriving complete with many suitcases.

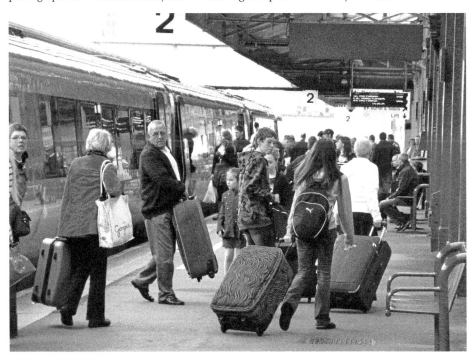

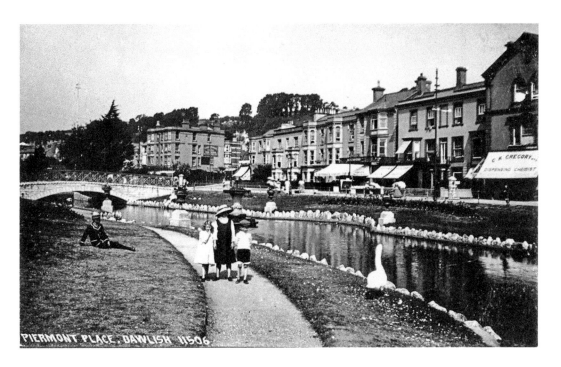

Piermont Place, Dawlish

Dawlish was originally a small fishing port and later became a popular seaside holiday resort with the introduction of the railway in the 1800s. The older photograph shows Piermont Place and a swan can be seen beside the stream that runs down towards the sea. Dawlish is well known for its black swans which were introduced by John Nash who brought them back from New Zealand.

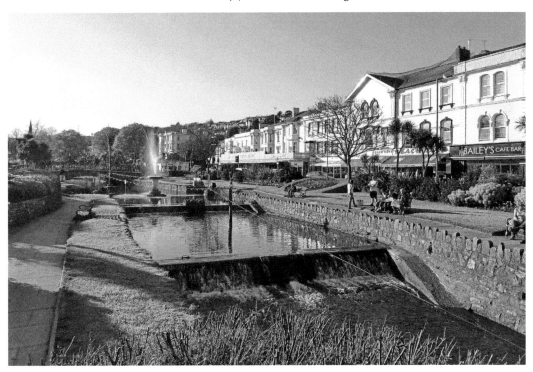

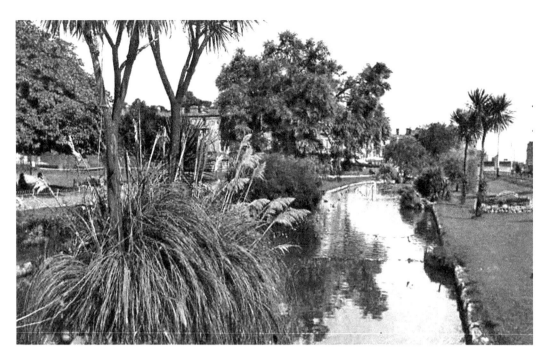

The Gardens at Dawlish

The ornate gardens at Dawlish were originally built in the 1800s after the land was acquired by John Edye Manning. Today, they are more commonly known as 'The Lawn'. Also in the early 1800s, the Strand and Brunswick Place were built nearby.

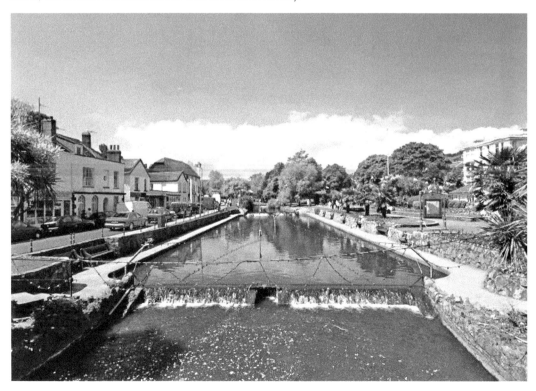

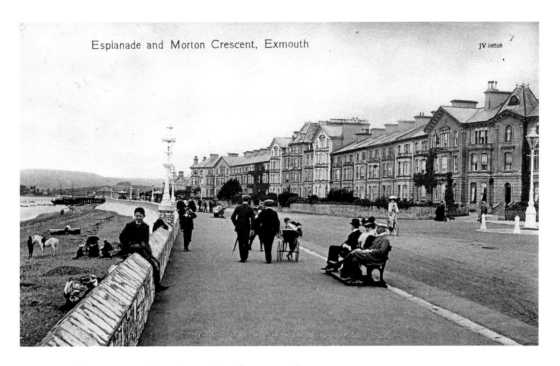

An Afternoon Stroll on the Esplanade, Exmouth

In the earlier photograph, people enjoy a walk along the Esplanade at Exmouth. A small boy is sitting on the sea wall and a lady, complete with a large hat, is riding a bicycle on the road nearby. A white horse can be seen on the beach, perhaps waiting to be ridden by local children.

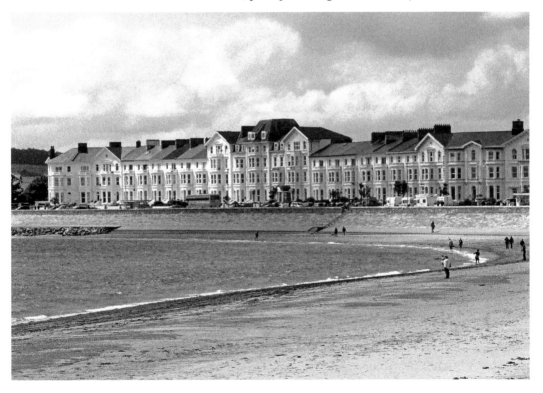

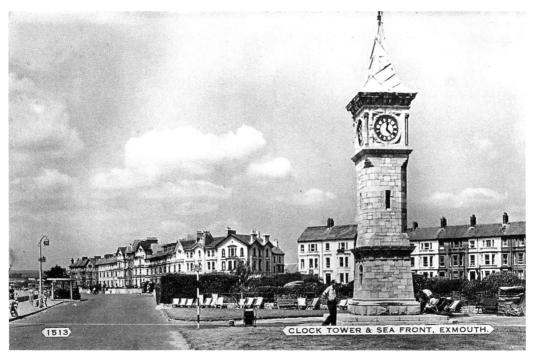

CLOCK TOWER & SEA FRONT, EXMOUTH.

1513

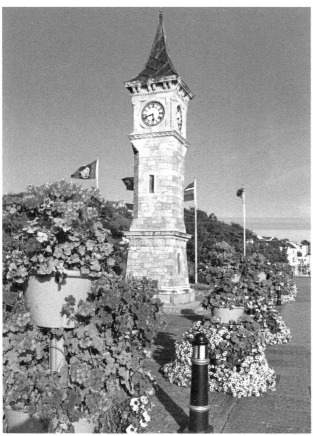

The Clock Tower at Exmouth
The clock tower was built in 1897 to commemorate Queen Victoria's Diamond Jubilee. It was designed by architects Kerley and Ellis and is Grade II listed. In the older photograph, deckchairs have been placed near the clock so that visitors can enjoy the view.

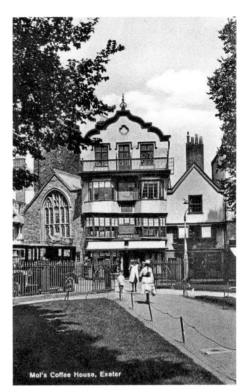

Mol's Coffee House, Exeter

Mol's Coffee House, Exeter

The older photograph shows Mol's Coffee House in Cathedral Close. Mol, an Italian, was said to have run a coffee house there in the sixteenth century and Drake, Raleigh and Hawkins were supposed to have met up there. However, it's believed that this story was invented in the late 1800s. The later photograph shows the view from the coffee house of the magnificent Exeter Cathedral.

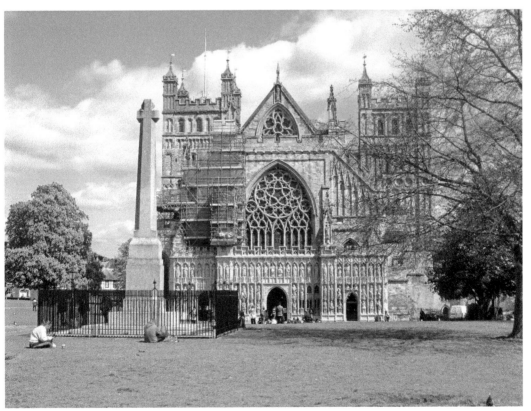

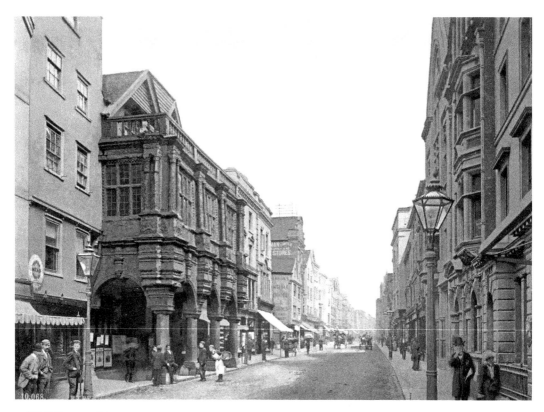

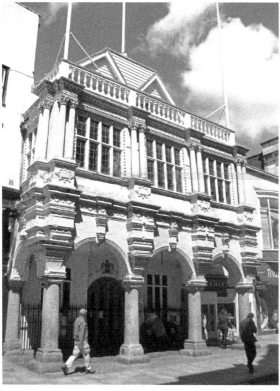

The Guildhall, Exeter

Parts of the Guildhall in High Street date back to 1160 and it's the oldest civic building in the country. The four granite columns date from 1593 and the area was used for regular weekly markets. A hook still hangs in the ceiling where scales were used to weigh meat.

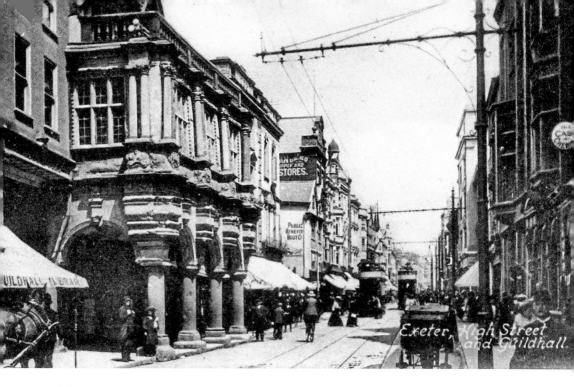

High Street, Exeter

The older photograph shows a busy scene in High Street. There are many pedestrians and a man, with a Panama hat, is riding a bicycle amongst them. Travelling towards him are two trams and horses and carts can also be seen. A snowy High Street can be seen in the later photograph.

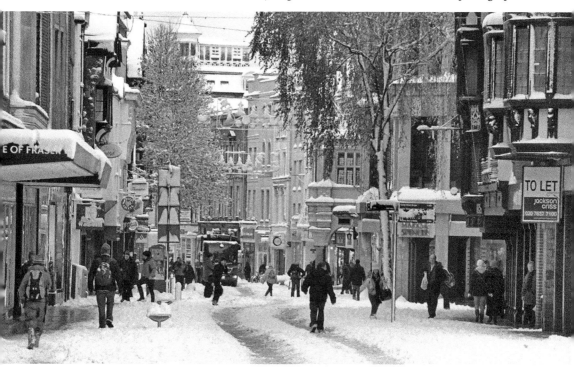

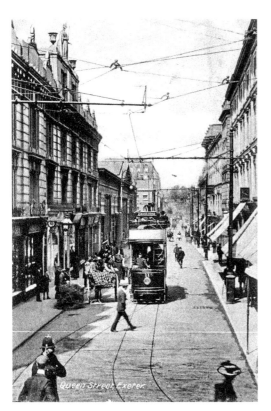

A Tram at Queen Street, Exeter
A tram heading along Queen Street can be seen in the earlier photograph. Its destination is given as Pinhoe Road. There is much activity in the picture and in the foreground a policeman is busy chatting to a passerby. The modern photograph shows a far more wintry scene.

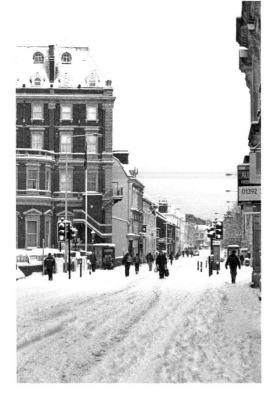

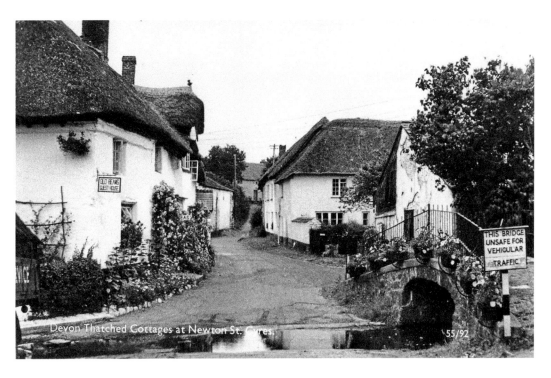

Devon Thatched Cottages at Newton St. Cyres

The Old Beams Guest House at Newton St Cyres
Like Cockington, Newton St Cyres contains many thatched cottages and appears to have changed little over the years. In both photographs, there is still water running across the road and a notice in the later picture says 'Try Your Brakes'. The Old Beams Guest House appears to be long gone.

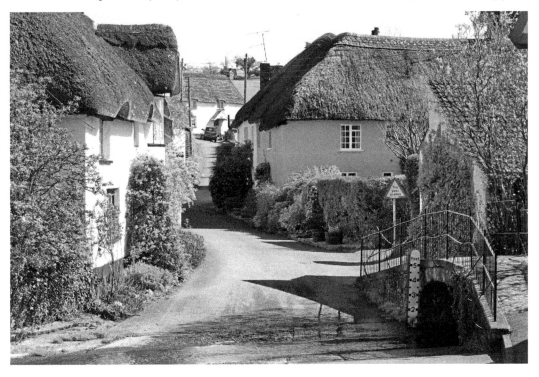

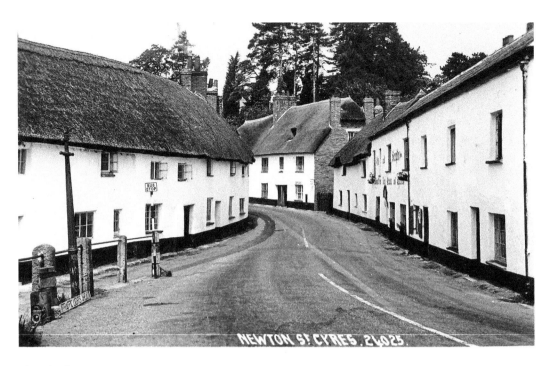

Thatched Cottages at Newton St Cyres

The older photograph shows another view of the sleepy village of Newton St Cyres. A sign announces that there are traffic lights ahead although, even today, there appears to be very few vehicles. The public house on the right of the picture is the Crown and Sceptre.

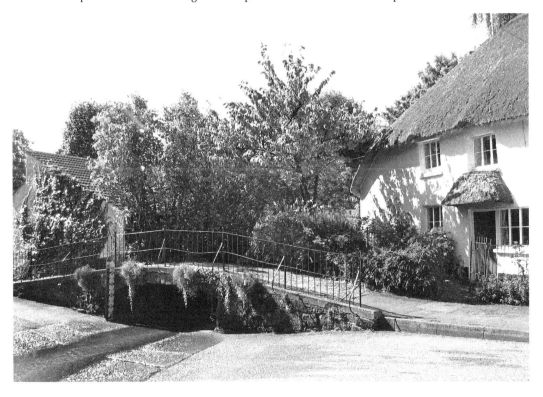

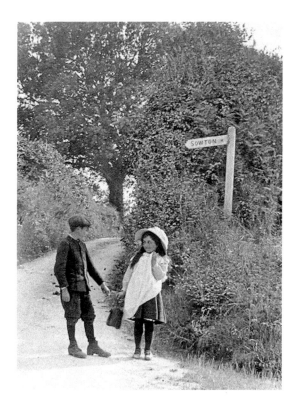

Children Walking Near Sowton

Two children walk the narrow country lanes close to Sowton in the earlier photograph. The boy is offering to carry the girl's bag for her. The later photograph shows the small village from nearby fields. Cows can be seen grazing on the right.

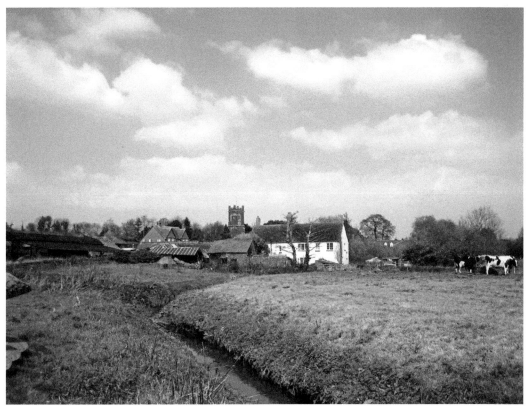

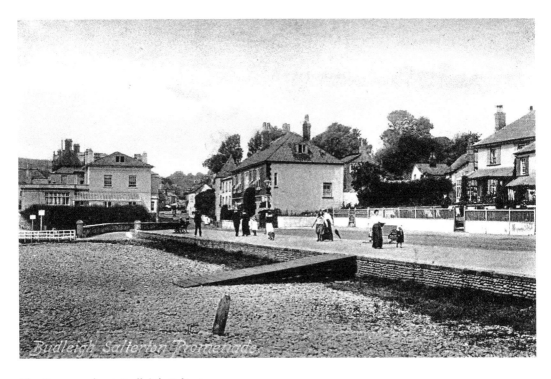

The Promenade at Budleigh Salterton

Salt was once manufactured at Budleigh Salterton, which gave the village its name. Sir John Millais produced the classic painting *The Boyhood of Raleigh* from the seafront promenade in 1870. The later photograph shows the village with its magnificent views out towards the sea.

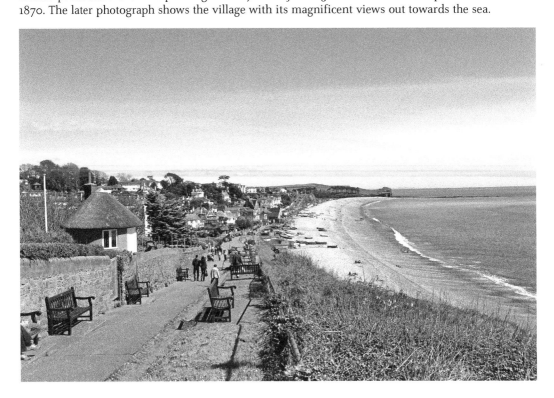

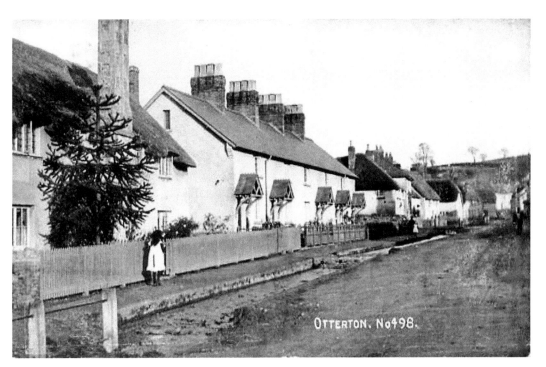

OTTERTON. No.498.

The Village of Otterton

Otterton is sheltered by the Otter Valley and features one of the oldest working water mills in the country. The area has been inhabited since the Stone Age and its name comes from the Saxons who arrived in AD 700. In the eighteenth century, smugglers were very active in the area and would bring back barrels of brandy and other contraband from France.

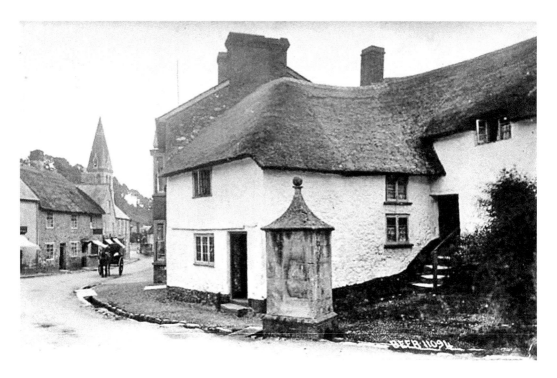

A Horse and Cart at Beer

The earlier photograph shows a very quiet scene at Beer. In the 1600s, almost three-quarters of the population of the village died from bubonic plague. Later a Spanish vessel was wrecked off the shore of the village and the crew settled there leading to residents of Beer, even today, being sometimes referred to as Spaniards.

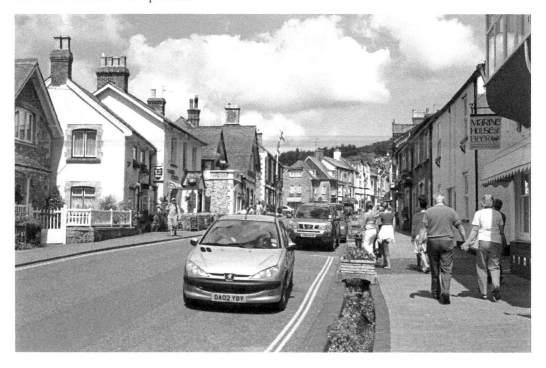

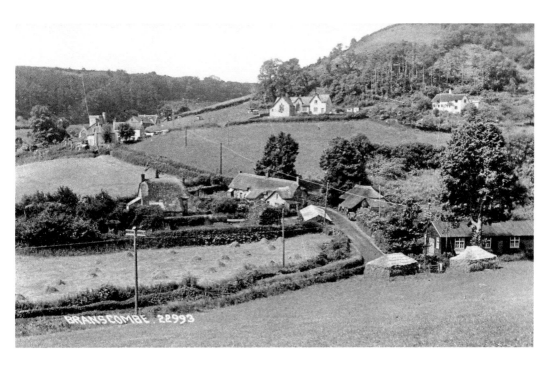

The Many Houses at Branscombe

For hundreds of years, Branscome was well-known all over the world for its manufacture of lace. Fishing and agriculture were also major industries. Both photographs show the view looking towards the village from nearby hills and little appears to have changed over the years.

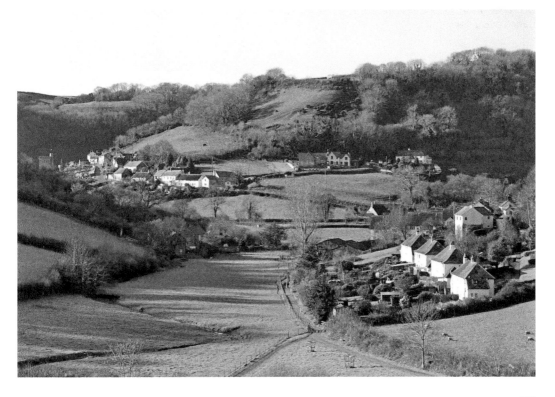

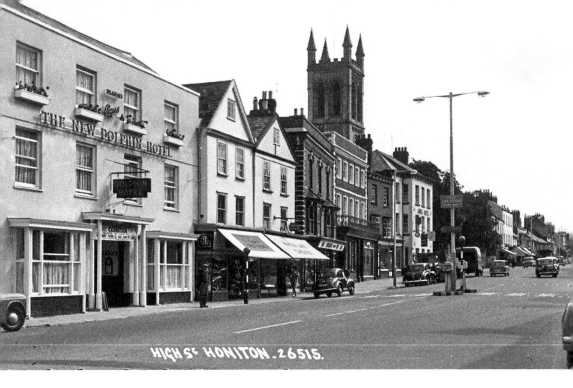

The New Dolphin Hotel at Honiton

The older photograph shows High Street in Honiton complete with many old cars. The New Dolphin Hotel can be seen on the left of the picture. William III stayed there in 1688 and during the Civil War the hotel was used as a military hospital. It is said to be haunted by the ghost of a young soldier.

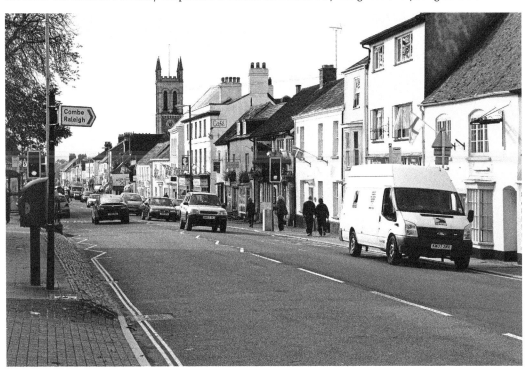

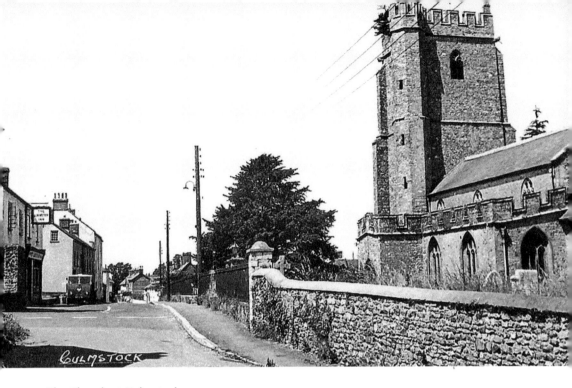

The Church at Culmstock

Both photographs show All Saints' Church in the small village of Culmstock. A church has stood in the village from before 1175, but the present church dates from the fifteenth century and has been added to over the years. It was renovated in 1879.

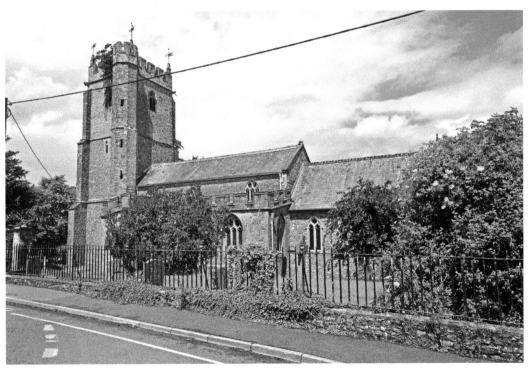

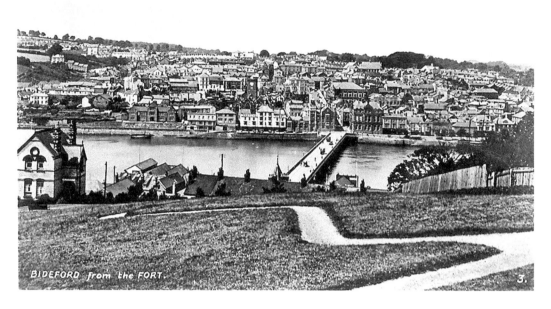

Bideford from the Fort

Bideford dates back to Roman times and was a place of trade in the thirteenth century. It is infamous for the Bideford witch trial of 1682 where three local women, Temperance Lloyd, Mary Trembles and Susannah Edwards, were hanged for practising witchcraft. They were the last people in England to be hanged for such a crime.

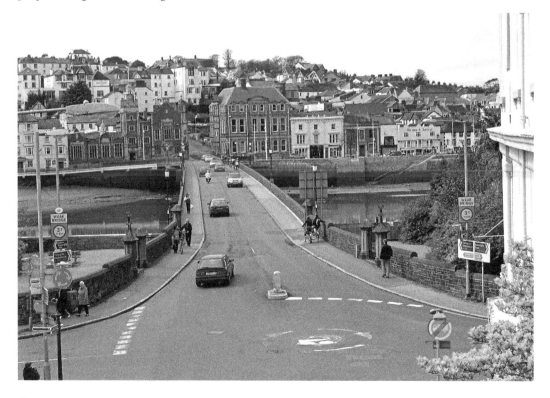

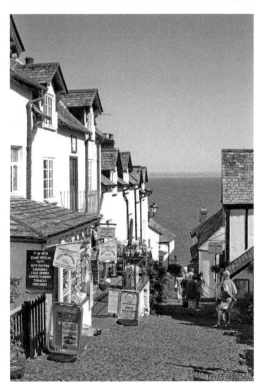

Donkeys at High Street, Clovelly
The older photograph shows donkeys taking goods up the steep cobbled streets of Clovelly. They were used to carrying items such as parcels, wood, fish from the quay as well as discarded rubbish. Donkeys are still used in the village and can be found in the top meadow during summer months.

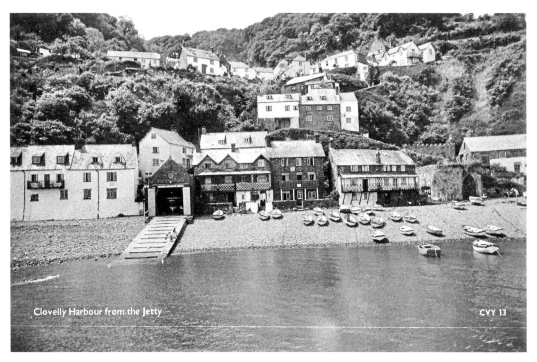

Clovelly Harbour from the Jetty

CVY 13

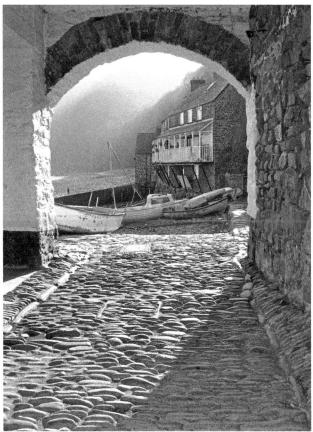

The Harbour at Clovelly

The older photograph looks
back to the village of Clovelly
with its many houses and
small boats. The village is
privately owned and has
been in possession of the
same family since 1738.
The later photograph shows
the harbour from a nearby
archway complete with cobbled
walkway.

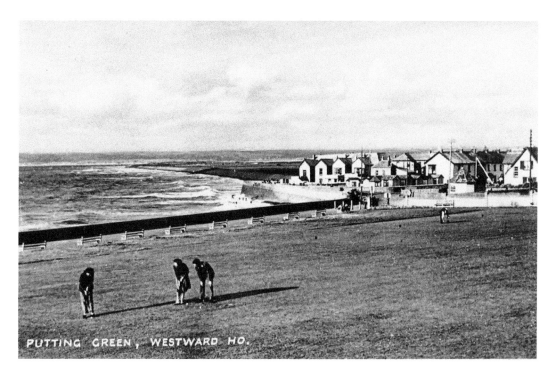

PUTTING GREEN, WESTWARD HO.

The Putting Green at Westward Ho!
The name of the village comes from Charles Kingsley's novel *Westward Ho!*, which was written in 1855 and became a bestseller. Local businessmen saw a chance to cash in on the popularity of the book and built the Westward Ho! Hotel to attract tourists.

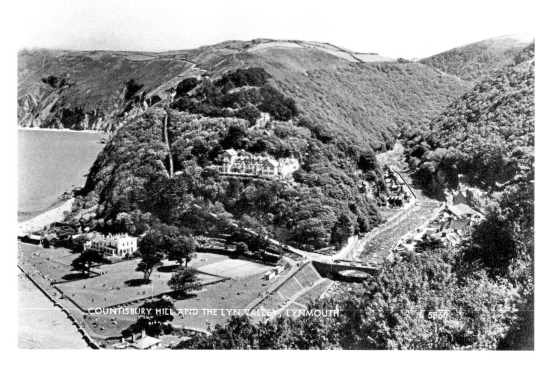

Countisbury Hill, Lynmouth
The older photograph shows Countisbury Hill in Lynmouth and the village can be seen on the right of the picture. Thomas Gainsborough honeymooned there and described it as 'the most delightful place for a landscape painter this country can boast'.

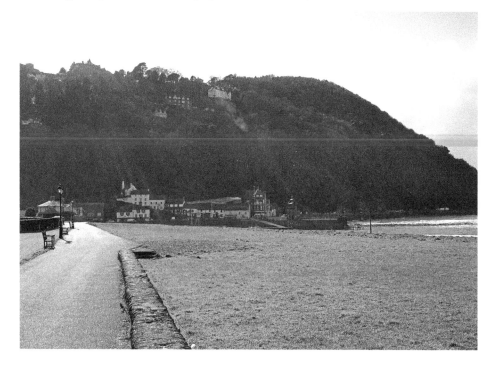

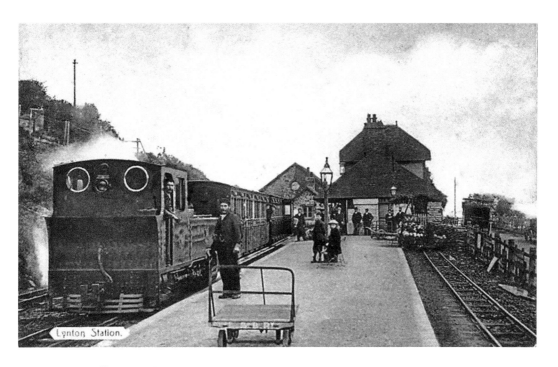

Lynton Railway Station

The older photograph shows the busy railway station at Lynton. The station opened in 1898 and closed in 1935. During that time, it served the twin towns of Lynton and Lynmouth. The later photograph shows the station house at Woody Bay.

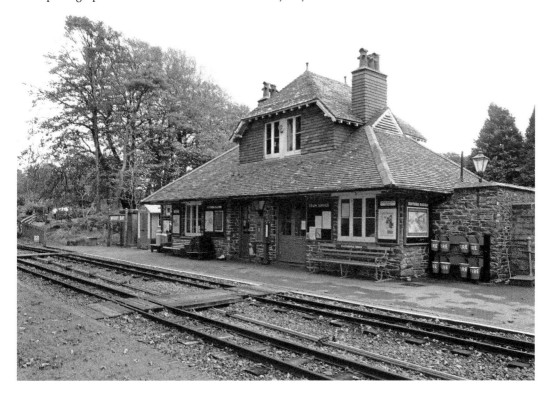

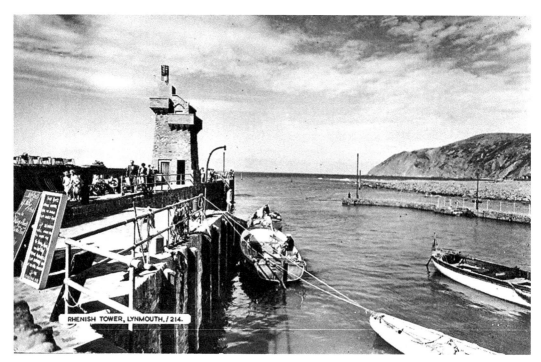

RHENISH TOWER, LYNMOUTH. / 214.

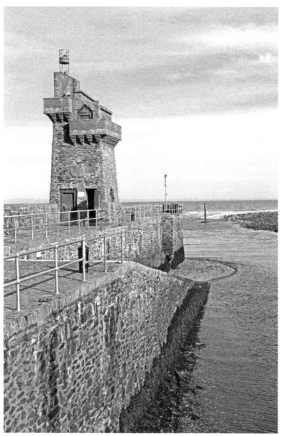

Rhenish Tower, Lynmouth

Rhenish Tower was originally built in the 1850s as a beacon to passing ships. It warned them of the dangers of the rocky coast line. The tower was swept away in the floods of 1952 but, along with other parts of Lynmouth, was later rebuilt.

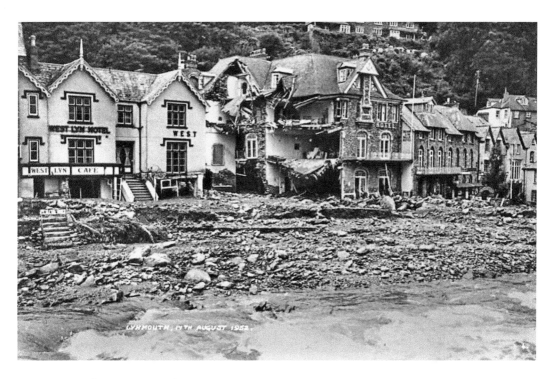

Destruction at Lynmouth

During the floods of 1952, over 100 buildings in Lynmouth were destroyed or seriously damaged. A total of 34 people were killed and 420 were made homeless. After the disaster, the village was rebuilt and the river was diverted around it.

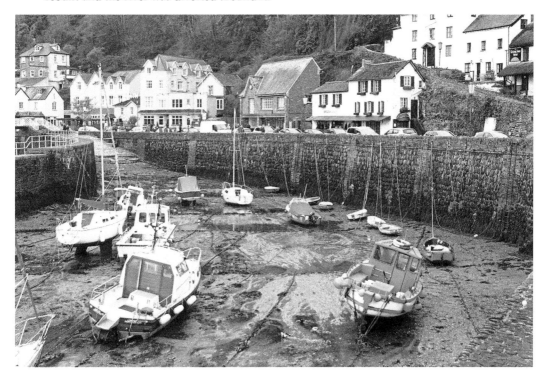

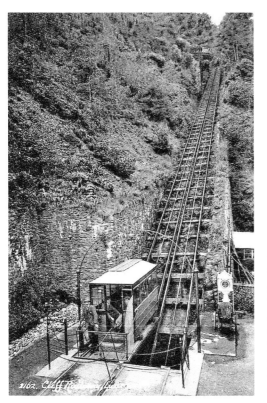

The Cliff Railway, Lynmouth

The Lynton and Lynmouth Cliff Railway is powered by water and travels regularly between the two villages. Building commenced in 1887 and it was completed three years later. It was constructed because holidaymakers arriving at Lynmouth by paddle steamer had great difficulty making their way with their baggage up towards the village of Lynton.

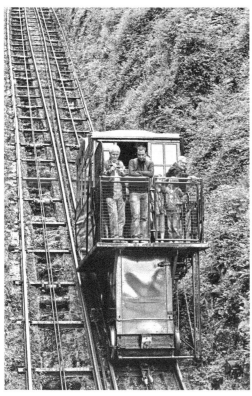

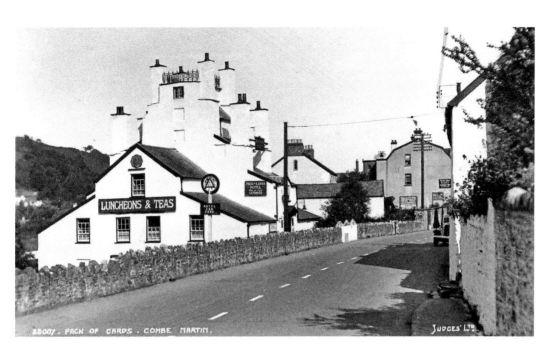

The Pack o' Cards at Combe Martin

Both photographs show a unique building, the 'Pack o' Cards' at Combe Martin. It was built in 1700 by George Ley and was reputedly funded by his gambling successes. The building was based on a deck of cards and originally had fifty-two windows, one for every card.

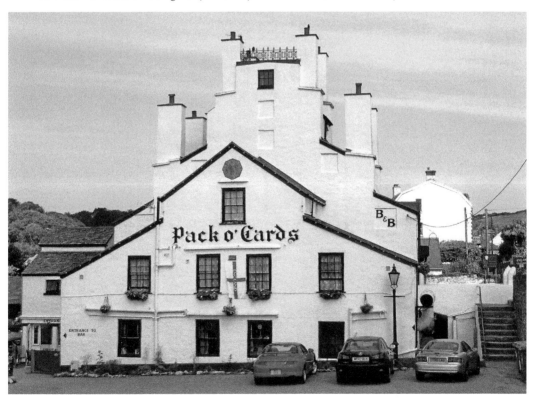

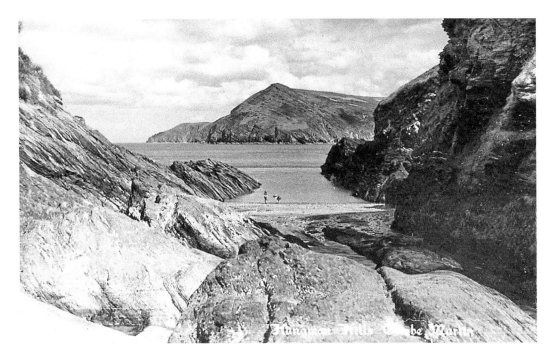

Hangman Hills, Combe Martin

The hills at Combe Martin are known as Great Hangman and Little Hangman. Although the name suggests something grisly occurring there, there is no record of public executions on the hills and the name is thought to be derived from a Saxon word.

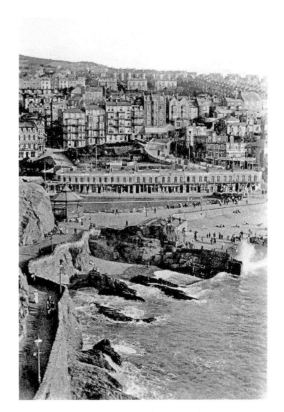

Ilfracombe from Capstone Hill

Both photographs look towards the seaside resort of Ilfracombe. From Capstone Hill there are magnificent views all over the town. The novelist Fanny Burney stayed in Ilfracombe in 1817 and her diary records early nineteenth-century life in the town including the capture of a Spanish ship.

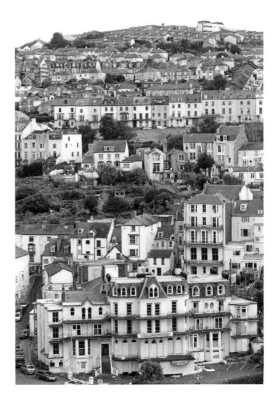

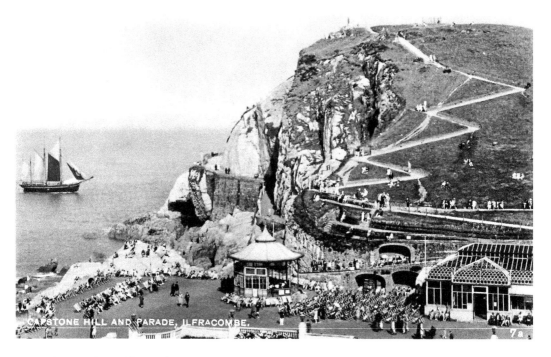

The Parade at Ilfracombe

The older photograph shows the Parade and bandstand at Ilfracombe. Many people have gathered in deckchairs to watch the next performance. In the background, the more adventurous can be seen climbing the winding paths of Capstone Hill. The later photograph shows the view from the harbour.

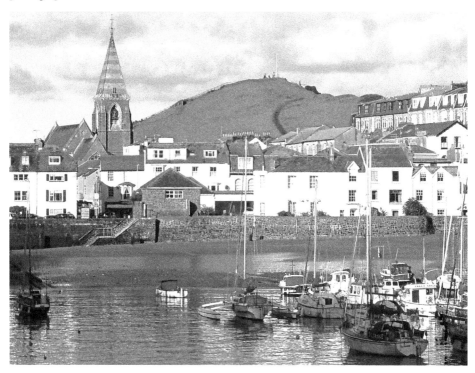

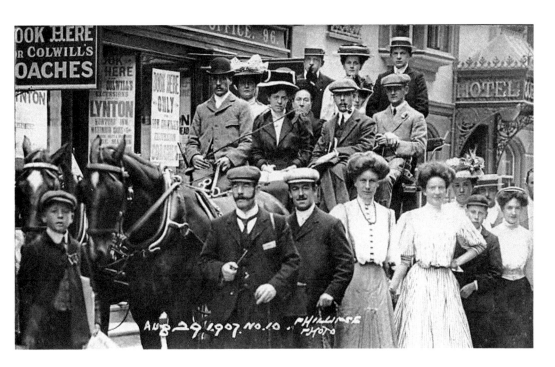

High Street, Ilfracombe

The older photograph shows finely-dressed passengers in High Street in Ilfracombe in August 1907. An advert can be seen for 'Colwill's Coaches' and one of the destinations advertised is Lynton. The later photograph shows High Street today.

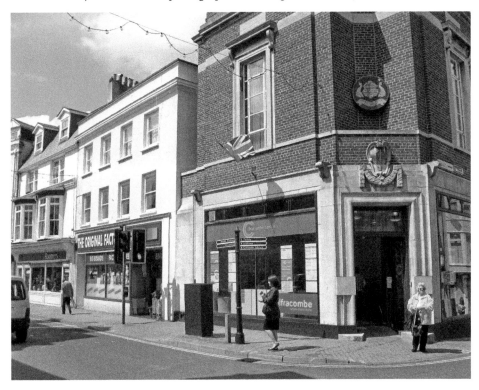

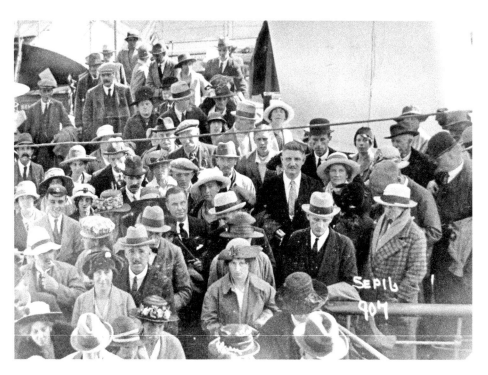

Passengers Disembarking from the *Devonia* at Ilfracombe
Several boats were used to take passengers out on sightseeing trips along the coast during the summer months. These included the *Devonia, Rowena, Mary* and *Vivian.* During other times of the year, they were used as fishing boats. The later photograph shows the harbour today.

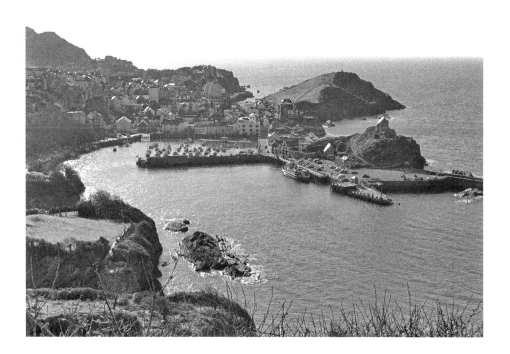

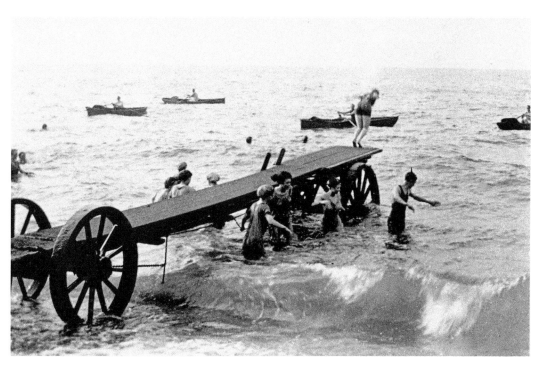

Fun at the Seaside

Swimmers dive from a wheeled platform in the earlier photograph and rowers oversee the action from further out at sea. Many of the swimmers are wearing bathing caps. The later photograph shows three female body boarders taking part in a sport which is very popular on today's beaches.

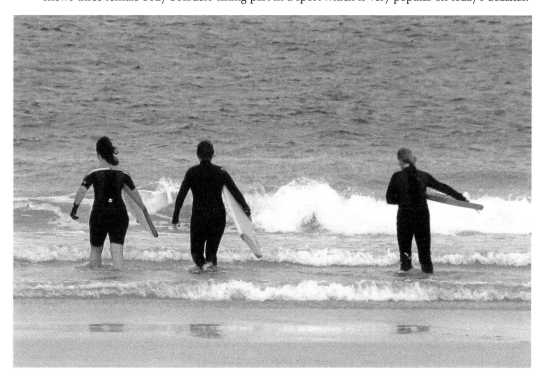

Changing Huts at Woolacombe

The older photograph shows many changing huts at Woolacombe and people can be seen in their deckchairs sitting in front of them. During the Second World War, the beach was used for training by American personnel because it was said to resemble Omaha Beach in Normandy.

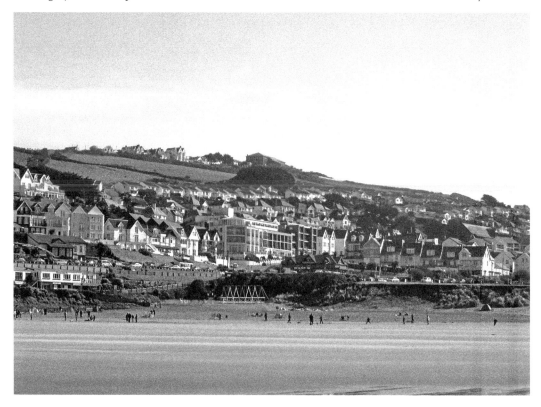

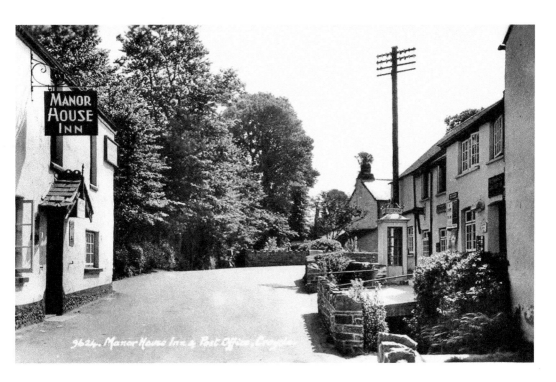

The Manor House Inn and Post Office at Croyde

The two photographs show views of the village of Croyde. The first shows the Manor House Inn on the left and the post office on the right. Outside the post office is a concrete telephone box. The later photograph shows some of the picturesque cottages within the village. Many have thatched roofs.

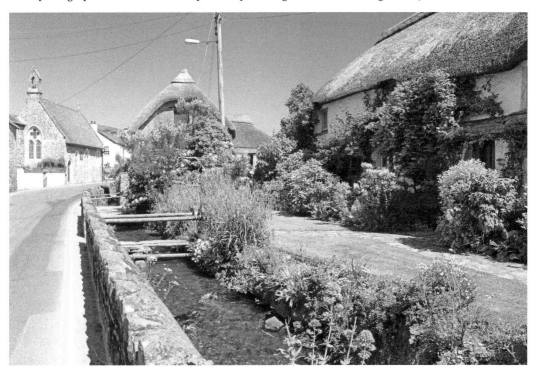

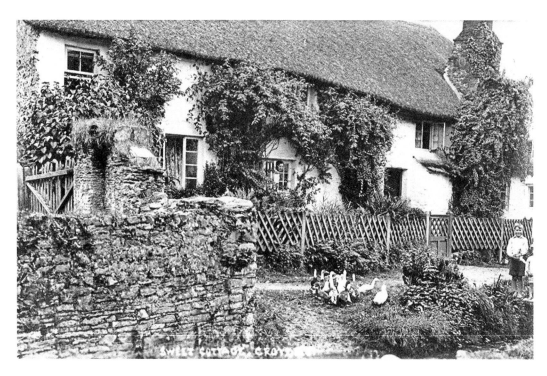

Sweet Cottage, Croyde

Two children together with a gaggle of geese can be seen outside Sweet Cottage in Croyde in the earlier photograph. The village has many quaint thatched cottages and the area attracts many tourists. Several campsites have been set up nearby to accommodate holidaymakers.

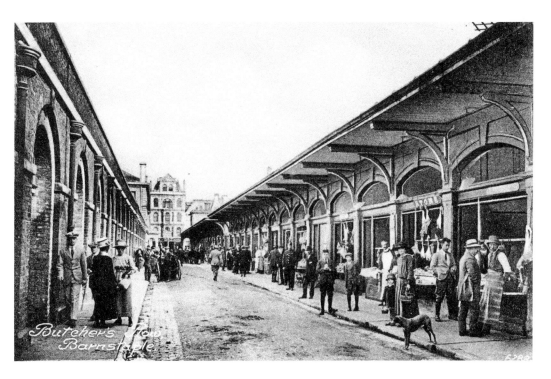

Butcher's Row, Barnstaple

Butcher's Row was built in the 1850s and comprises of thirty-three shops. It was built at the same time as the Pannier Market. The earlier photograph shows many people gathered there to buy produce and a hopeful dog waits for a bone. Today, the shops continue to trade.

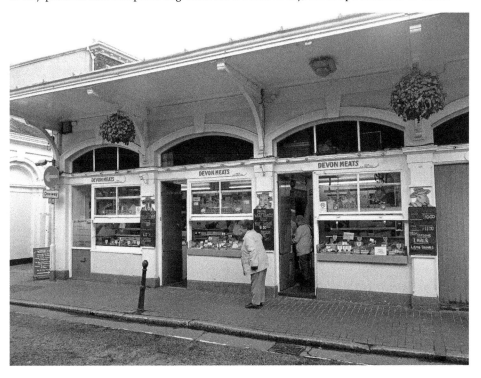

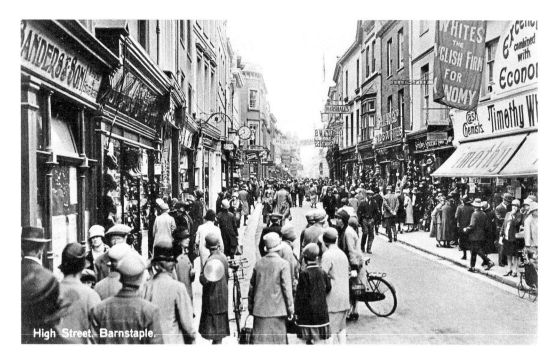

High Street. Barnstaple.

Many Shoppers at Barnstaple

The earlier photograph shows a very crowded scene in High Street in Barnstaple. From the clock, it is 11.40 a.m. in the morning and many housewives seem to be getting their weekly shopping. The later photograph shows many modern-day shoppers doing exactly the same thing almost 100 years later.

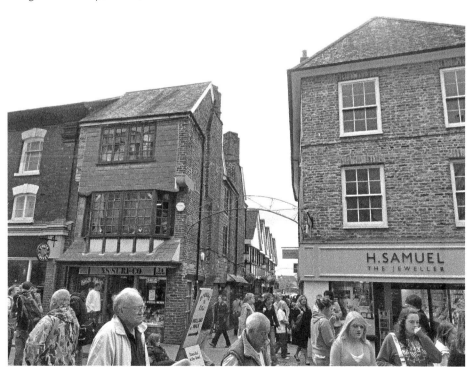

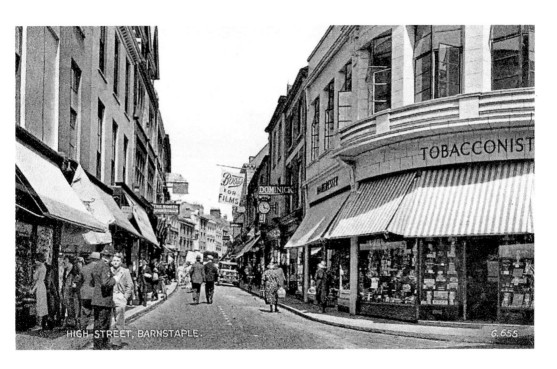

High Street, Barnstaple

Again the clock in High Street tells us the time the photograph was taken: 11.15 a.m. Shop fronts advertise *The North Devon Herald*, 'Dominick's' and 'Boots for films'. Several women can be seen carrying wicker shopping baskets. The later photograph shows Barnstaple from the river.

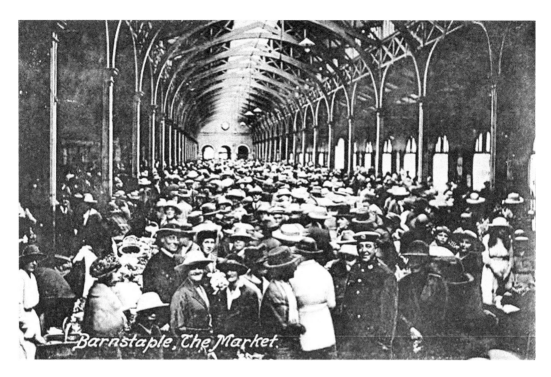

The Market at Barnstaple

The older photograph shows a very busy Pannier Market at Barnstaple. It first opened in 1855 and was originally called the vegetable market. Today, the market still opens on Tuesdays, Fridays and Saturdays and sells a variety of goods including antiques and collectables.

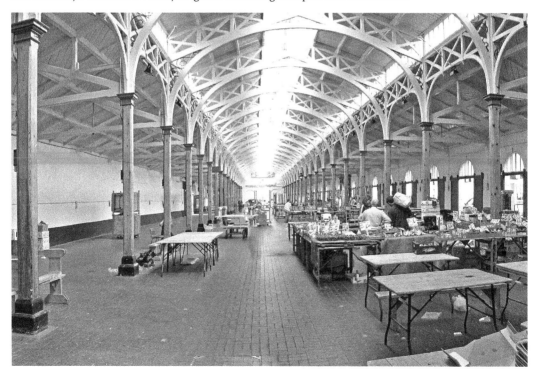

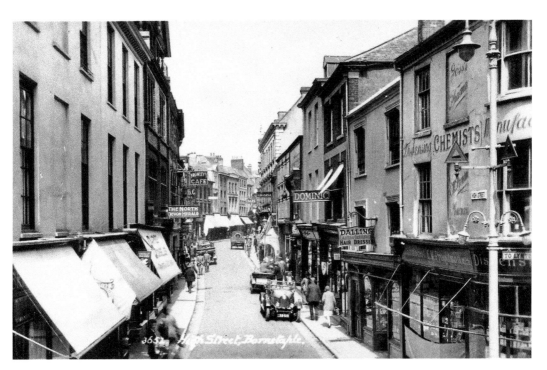

Old Cars at Barnstaple

The older photograph features some lovely classic cars. The names of many of the businesses can be seen including 'E. W. Proudman – Dispensing Chemist', 'Dalling – the ladies and gentlemen's hairdresser', 'Bromley's Café' and 'Dominick's', who sold teas and ices. The later photograph shows High Street on a cold December evening.

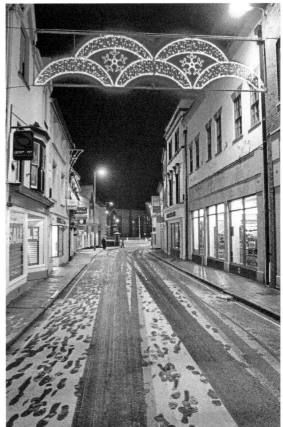

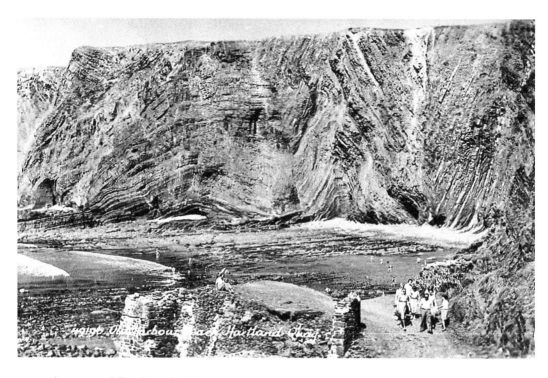

The Steep Cliffs of Hartland Quay

Both photographs show Hartland Quay with its steep, dramatic cliffs. The quay was originally constructed in the late 1700s but was swept out to sea in 1887. The area was featured in the 2008 BBC adaptation of *Sense and Sensibility*.

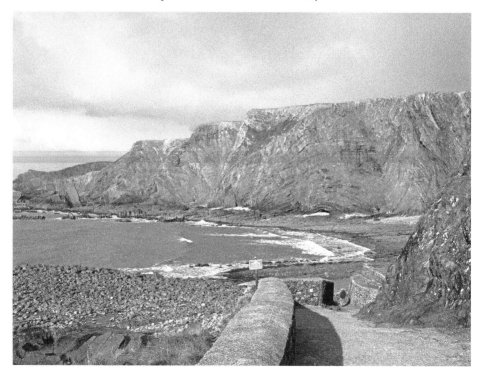

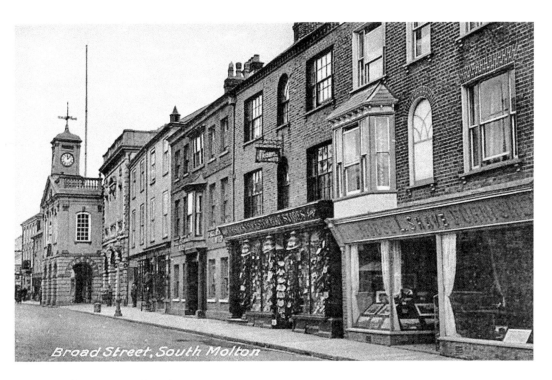

Broad Street, South Molton

Both photographs show Broad Street in South Molton and many of the older buildings have remained much the same over the years. On 14 March 1655, a street fight, which lasted more than 3 hours, led to the capture of Sir John Penruddock who was a Cavalier during the Civil War. He was later beheaded for his part in the rebellion.

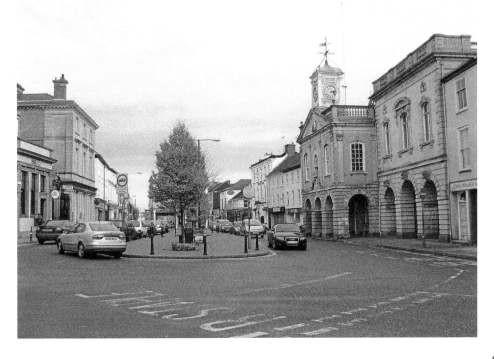

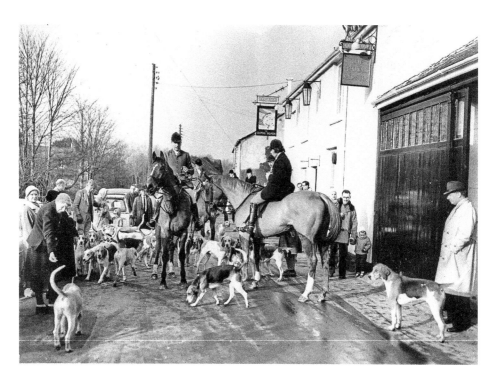

The Hunt at Horrabridge

The older photograph shows a hunt meet at Horrabridge outside the Leaping Salmon Inn. The huntsmen are accompanied by many dogs. Horrabridge's main industry was the mining of copper and tin which went on until the early twentieth century. The later photograph shows a quiet, snowy scene of the village.

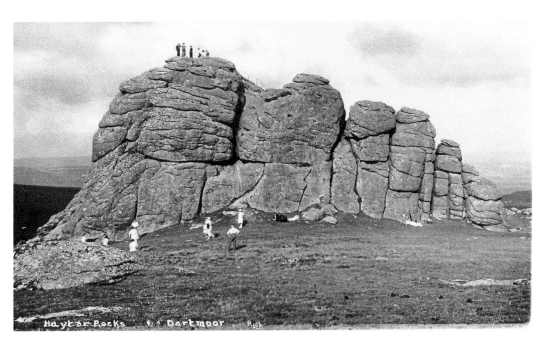

Haytor Rocks on Dartmoor

The eerie backdrop of Haytor Rocks was used as the inspiration for Sir Arthur Conan Doyle's Sherlock Holmes novel, *The Hound of the Baskervilles*. There are several disused granite quarries nearby and stone from here was used in the construction of London Bridge. Today, the area is popular with both tourists and climbers.

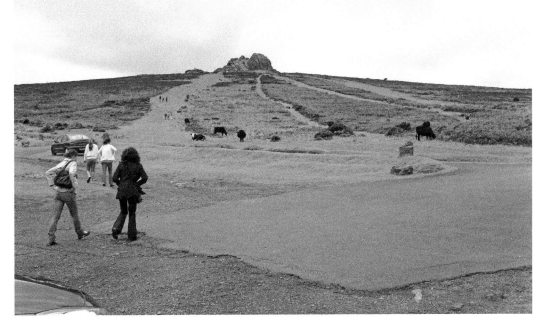

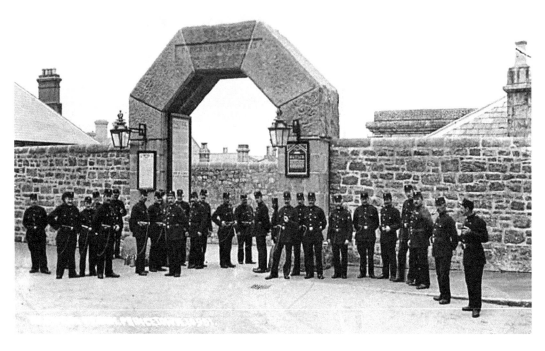

Warders at Dartmoor Prison, Princetown

The prison was built between 1806 and 1809 to house captives of the Napoleonic Wars. It also held American prisoners from the war in 1812. It was reopened as a civilian prison in 1920 and at one time contained some of the country's most serious offenders.

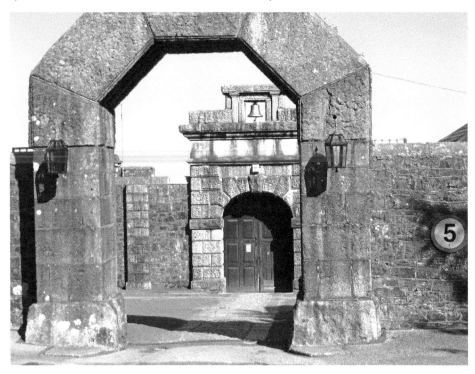

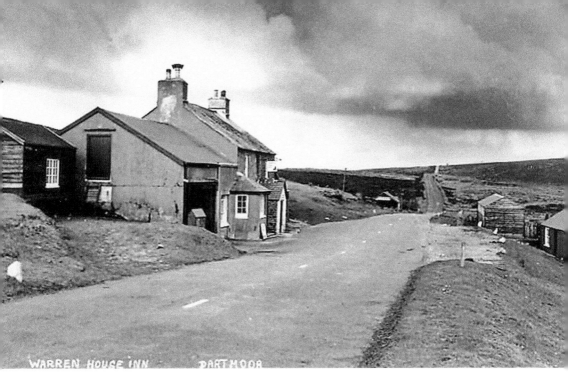

The Warren House Inn, Dartmoor

The present inn was built in 1845 and it is said that the fire in its grate has burnt continually ever since. Prior to 1845, the inn stood on the opposite side of the road and was named 'New House'. High up on Dartmoor, it is said to be one of the loneliest inns in the country.

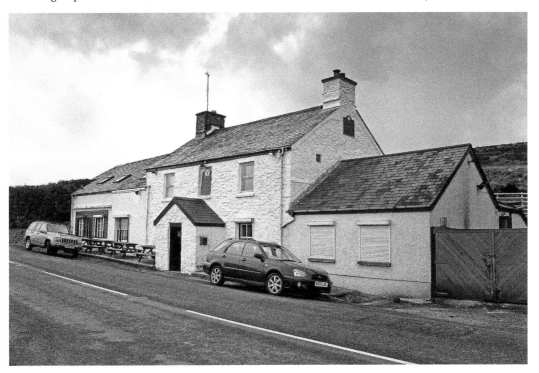

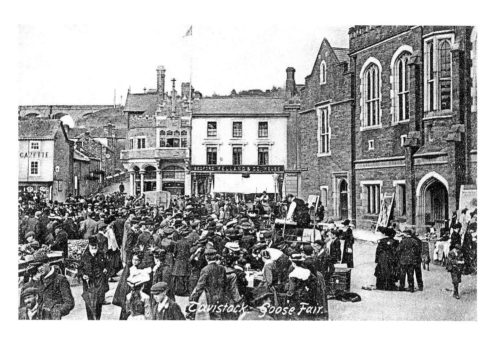

The Goose Fair, Tavistock

Many people can be seen gathered at the Goose Fair (better known as 'Goosey Fair') in Bedford Square, Tavistock, in the older photograph. Many of the buildings remain the same although a more modern building, built to look older, would later be erected where the *Gazette* building stands.

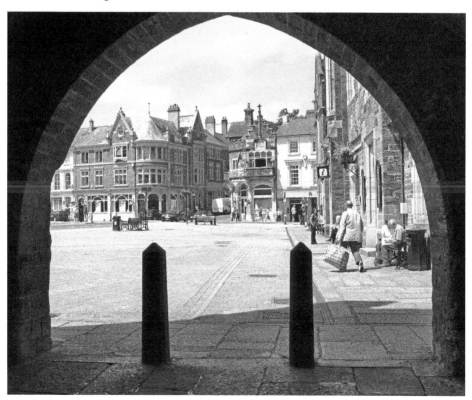

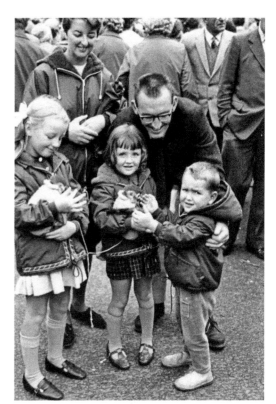

Little Monkeys at Goosey Fair, Tavistock
In the older photograph, Kim Precious and her family attend Goosey Fair in the early 1960s. Each is holding a small monkey. The fair dates back to the twelfth century. The later photograph shows Tavistock today looking towards Bedford Square.

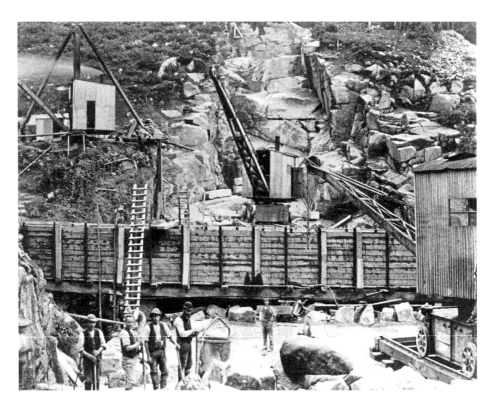

The Building of the Dam at Burrator

Work started on the construction of the dam at Burrator in 1883 and was officially opened in 1898 by the Mayor of Plymouth, Councillor J. T. Bond. The total cost was £178,000. In the older photograph, the laborious construction of the dam being built can be seen.

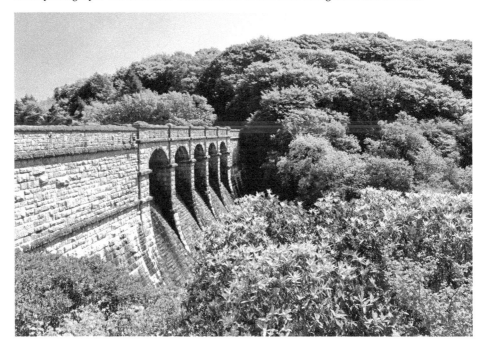

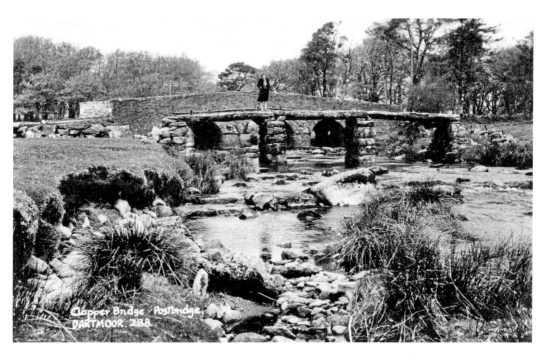

The Clapper Bridge at Postbridge

Although said to be prehistoric, the clapper bridge at Postbridge was actually built in the 1300s so that pack horses could be used to transport tin to the nearby town of Tavistock. Each slab of the bridge is 13 feet long and weighs over 8 tons.

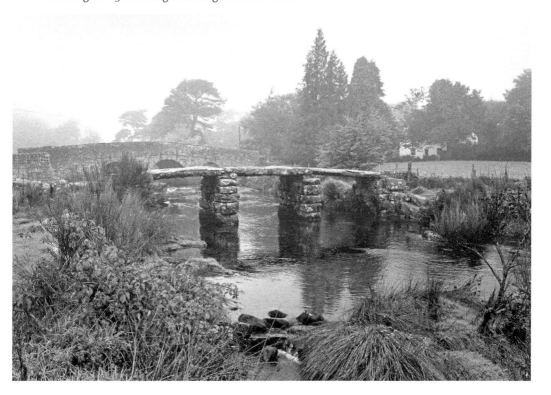

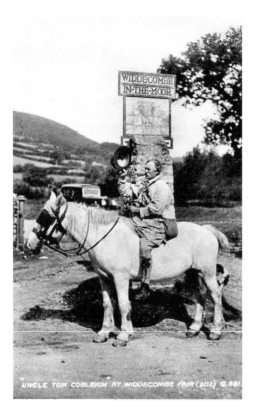

Uncle Tom Cobleigh at Widdecombe Fair
The earliest record of the fair at Widdecombe was recorded in the *Plymouth Gazette* in 1850 when it was described as a 'cattle fair'. It mainly sold livestock but in 1920 it also incorporated a children's sports day. By 1933, local arts and crafts were also sold.

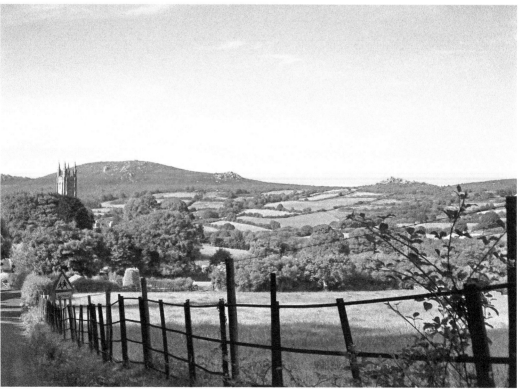

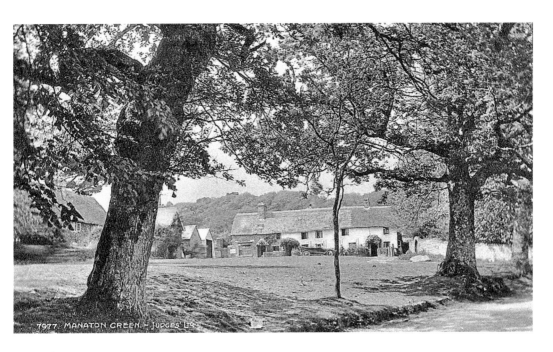

The Green at Manaton

The older photograph shows a quiet green at Manaton. An old car is parked outside one of the cottages. The later photograph sums up an English countryside complete with an ongoing cricket match. The church dates from the fifteenth century and is dedicated to St Winifred.

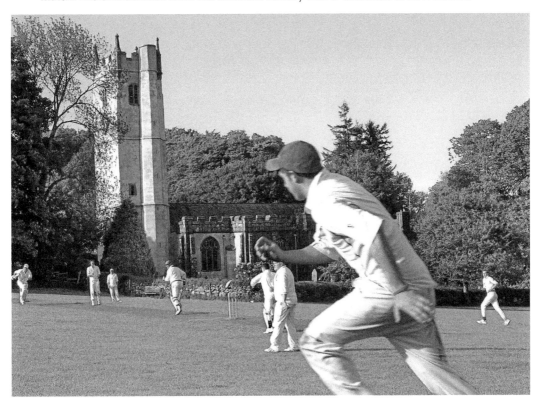

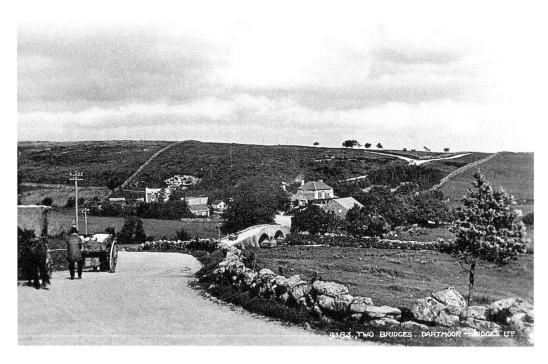

Two Bridges, Dartmoor

Two Bridges is situated to the north-east of Princetown. The name 'Two Bridges' arose because two bridges were needed to cross both the West Dart and the River Cowsic. By 1891, only one bridge remained but, today, there are once again two bridges, although one is a lot more modern than people imagine.

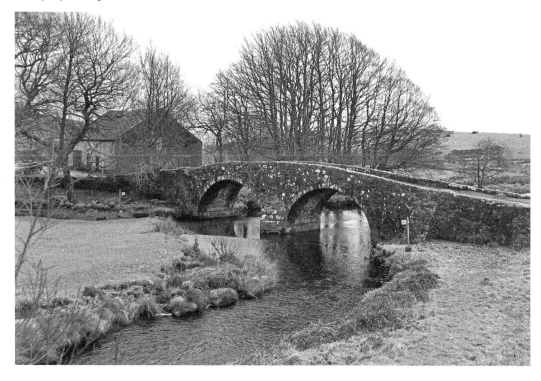